ROAD
LIFE

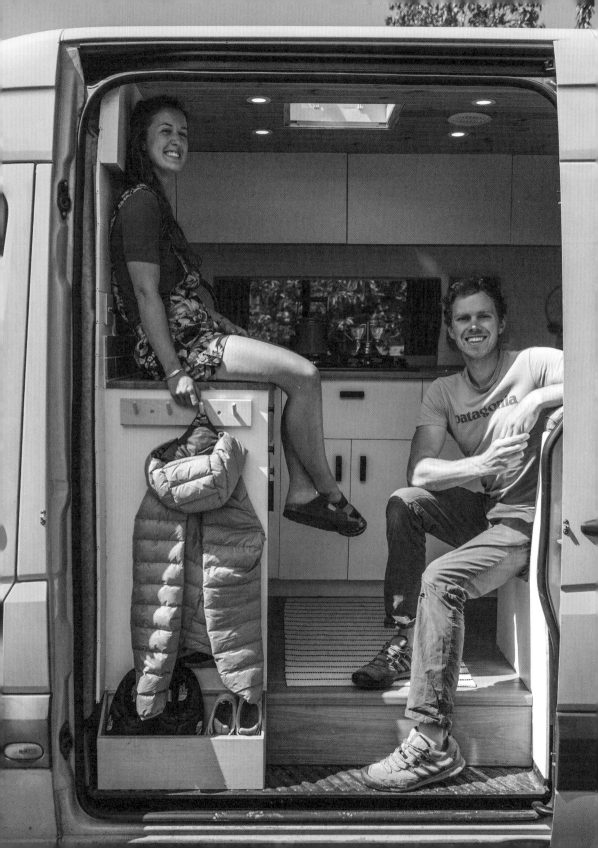

A SLOW LIFE GUIDE

ROAD LIFE

An inspirational
guide to living
and travelling
on four wheels

Sebastian Antonio Santabarbara

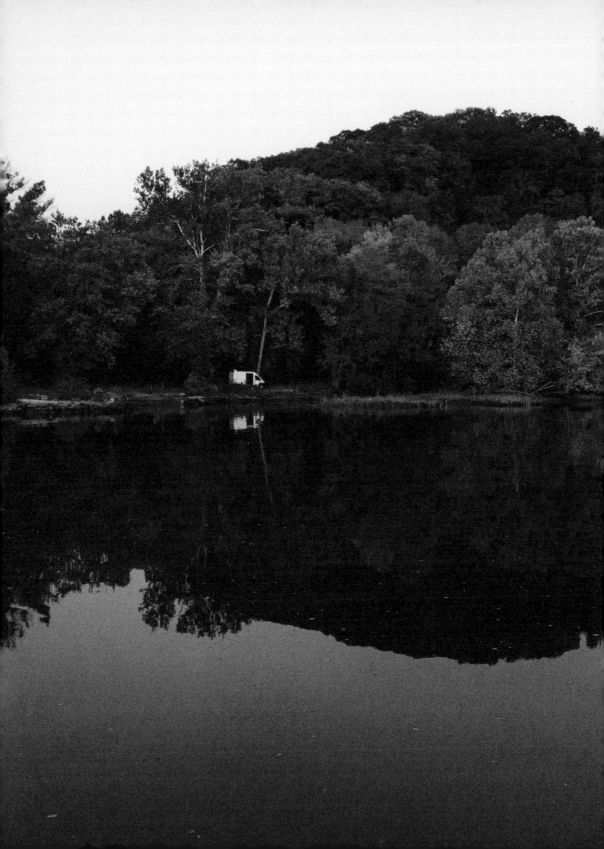

CONTENTS

Introduction 7

Digital Nomads 13

Weekend Warriors 45

Thrillseekers and Adventurers 71

Shoestring Travellers 101

Cleaner Living 131

Off-Grid Explorers 155

Directory 186

Index 187

Acknowledgements 191

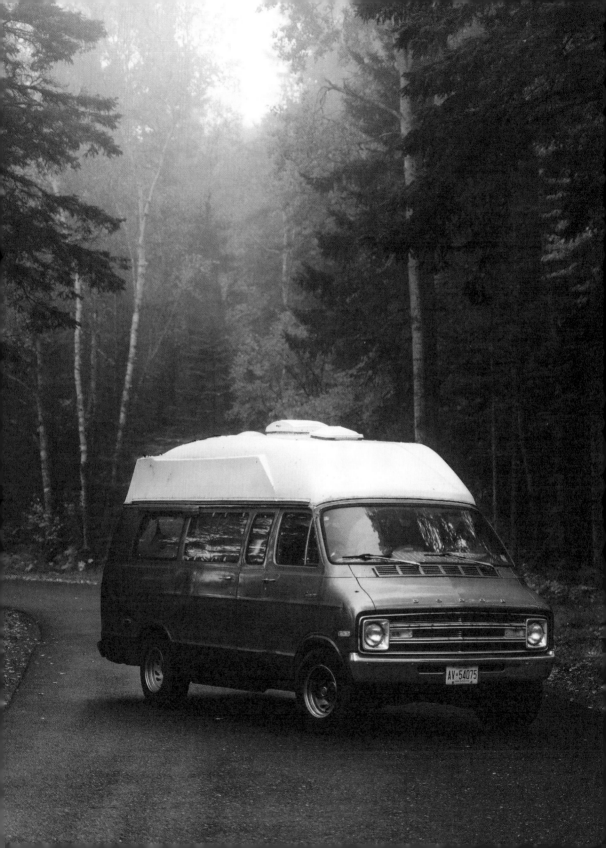

INTRODUCTION

Welcome to your first foray into the world of road life, a nomadic movement that has captured the hearts and minds of millions of people all over the world. If you've purchased this book and are currently reading this introduction, then I'm going to assume that you're one of those people too, dreaming of life on the open road and the idea of taking a travelling tiny home to some of the most beautiful places on the planet.

But just what *is* road life, and how do we go about swapping the nine to five for a round the world drive?

What are the benefits of owning and travelling in a camper, and is it a legitimate option for people with full-time jobs or families?

Luckily for you, this book answers all those questions and more, as well as providing advice and inspiration through the stories of road lifers that live and breathe all things alternative living.

From the glaciers of Alaska to the beaches of Australia, *Road Life* delves into the finer details of how to live life on your own terms, whether you're looking to live and travel on a budget, thinking about travelling part time, or are desperate to swap the office for a reclining chair at the side of the ocean.

Back in 2017 at the age of twenty-seven, I was working in a job that I didn't enjoy, spending all my money on rent, and feeling trapped in a life that just didn't feel right. I desperately needed a change, and after months of learning to drive, I passed my test and bought my first car; a Vauxhall Movano Maxi-Roof van. After six months of using every spare moment after work and on weekends to convert it, I moved into 'Vincent' full time. I lived in the UK while working for a year before quitting my job, selling my possessions, and heading out on the open road within 18 months of purchasing the van.

That van was the start of an adventure that not only kickstarted my career as a writer, but one that saw me living a sustainable lifestyle while travelling across two continents,

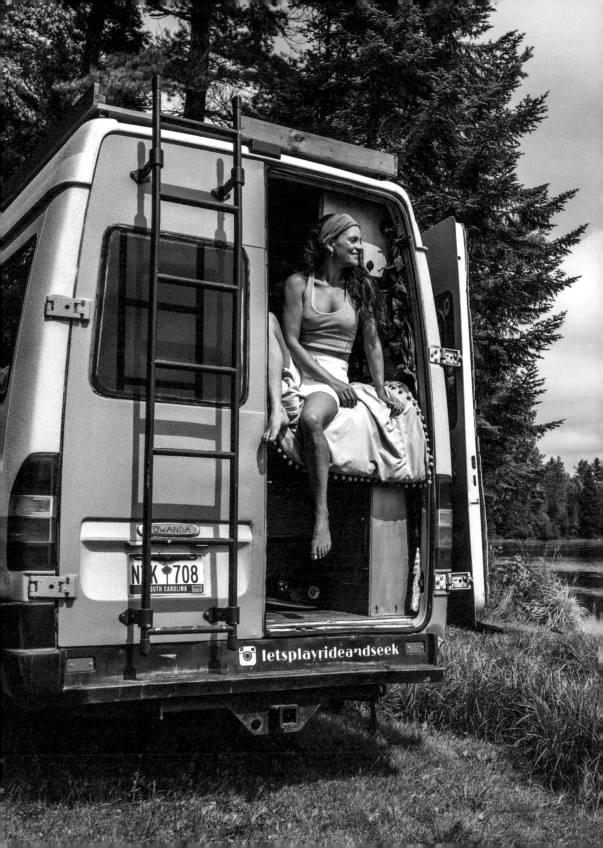

meeting incredible, like-minded people who were also chasing an alternative path, searching for the road less travelled and championing a life that 'goes against the grain'.

If, like I was, you're at that point of wondering how to get started and whether road life is truly for you, then you've come to the right place. Over the course of the book, you'll hear from people who have made a career out of exploring full time, as well as people who travel to build a cleaner world, and others that simply enjoy getting out into nature whenever they can.

I've had the pleasure of speaking to road lifers from all over the world, people at different stages in their lives and careers with different ideas of what life on the road means to them. Through the following chapters, you will discover self-made campers built on a budget through to luxurious builds that come with everything including the kitchen sink, covering all different styles of alternative living on the road with options and lifestyles to suit everyone.

Road Life is more than just a book about campers; it's a global snapshot of a movement that is quickly changing people's perceptions about what the future might entail. For each contributor who has shared their story, it's a piece of their journey frozen in time, a chance to tell the world about their goals for the road-life community while helping to make it a more inclusive place for all.

And of course, there are lots of pictures and travel tips that are bound to fill you with wanderlust.

So, whether you're living life off-grid, searching for that spark of adventure, or just interested in all things alternative living, *Road Life* is guaranteed to provide both intrigue and inspiration in equal measure.

But don't just take my word for it. Dive into our first chapter and meet some of the audacious individuals changing the definition of what 'a normal life' truly means.

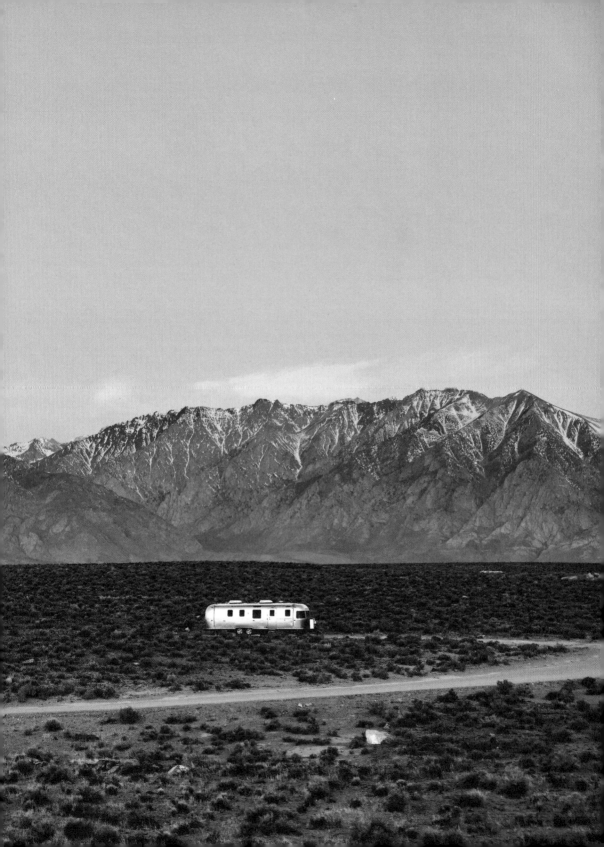

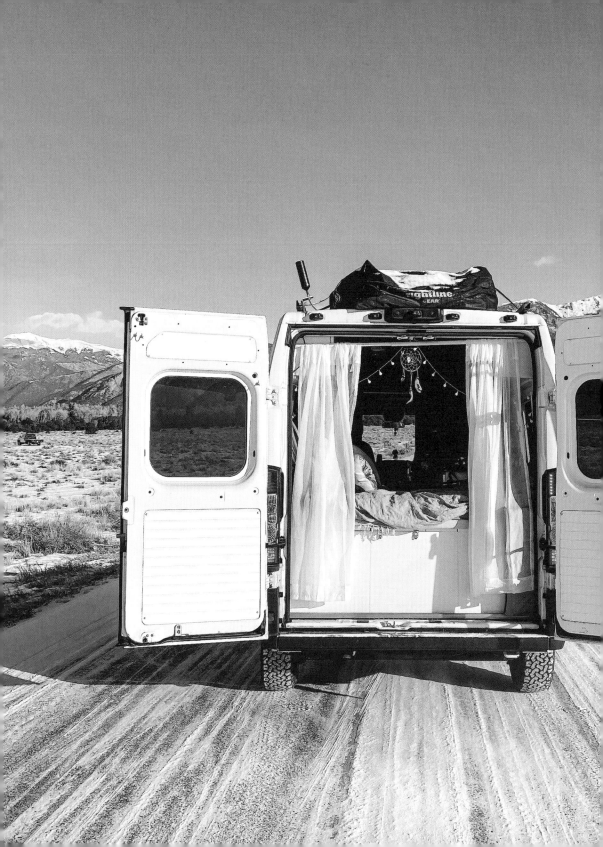

1

DIGITAL NOMADS

Working from home is slowly becoming a new normal for people all over the world, and for digital nomads, home is wherever they park it.

How many of us sit staring at glorious places on our computer screensavers, wishing to be anywhere other than a gloomy office? Leaving the rat race in search of something fresh and new has never been more possible thanks to the freedom of road life, and it's much simpler than you think.

Having the freedom to choose your own working rhythm while seeing the world at the same time does fantastic things for your mental health, creating a productive environment rife with creativity and positivity. Plus, when your office is on a mountain top or at the side of the ocean, Monday mornings aren't half bad.

Whether working as part of a larger team or selling handmade goods online just to fund your travels, these digital nomads are proof that work doesn't have to get in the way of your adventures, and that travel can be more than just a pipe dream.

THE INDIE PROJECTS

 @theindieprojects

 Portugal

Explore new places, meet new people

 2014 Mercedes Sprinter

Theo and Bee have dominated the alternative living movement since 2014. Along with their cats, Ginjey and Furrnando, they explore all aspects of tiny living and continually seek out new and exciting challenges to undertake, bringing the world onboard with them via their YouTube channel, *The Indie Projects*.

What started as a trip through Europe in a VW T4 with no heating quickly turned into a life-changing experience that saw Theo and Bee moving into the world of mobile content creation full time, leaving their jobs and making videos of their incredible road trips and interviews with other pioneers of the road-life movement.

Using fewer resources and living a more eco-conscious lifestyle had always been part of Theo and Bee's plan, but their new career was somewhat of a happy accident. Their tiny-home tours in the UK quickly went viral, and with demand for their inspiring content growing swiftly, so too did the need to upgrade their home. They bought and self-converted a Mercedes Sprinter into a stunning house on wheels, immediately moving from charging their equipment in restaurants and via a portable suitcase generator to taking advantage of a complete solar panel set-up that allows them to work and live off-grid. However, on dark, wintery days, the suitcase generator still puts in the odd appearance.

Theo and Bee upload their content by using either their motorhome internet or by utilizing a signal booster that strengthens the signal of free WiFi points on their travels. They can also hotspot from their mobile phones to upload videos and keep in touch with their ever-growing audience, many of whom are itching to move into the world of alternative living themselves.

Wild camping and working on location everywhere from the Arctic Circle to their newly acquired Portuguese homestead and editing from the comfortable living area in their Mercedes Sprinter, Theo and Bee have built their brand from the ground up. They work long hours and spend a lot of time creating meaningful and informative content, but their way of life has ultimately

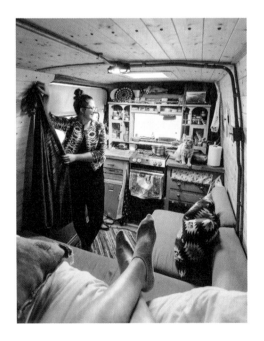

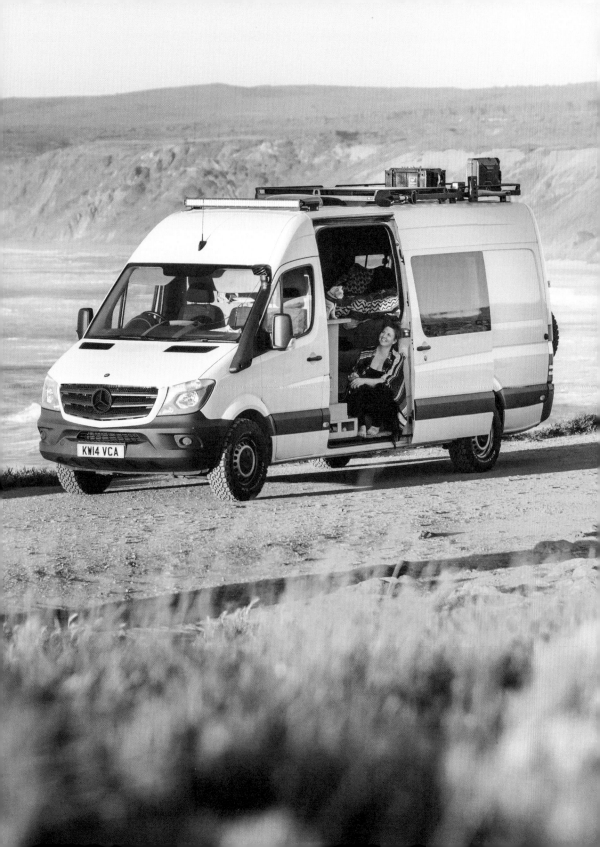

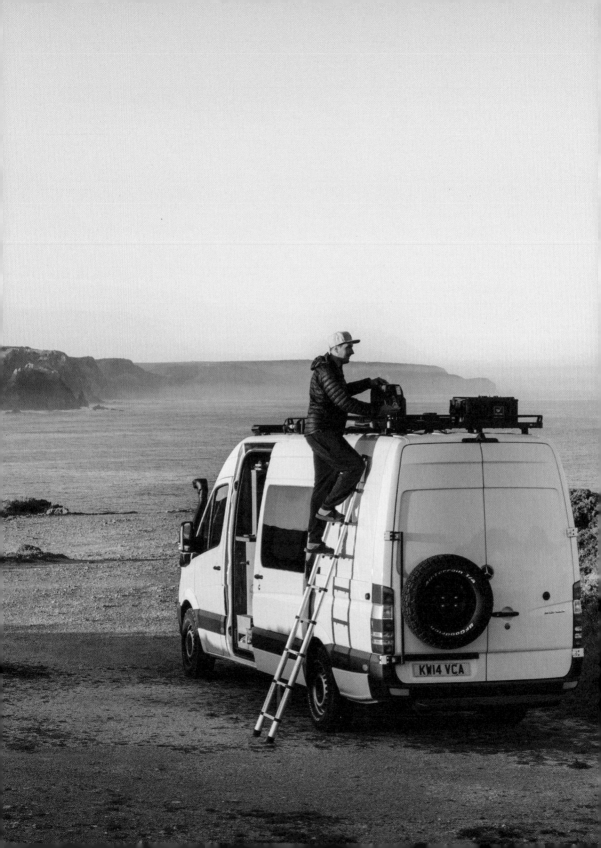

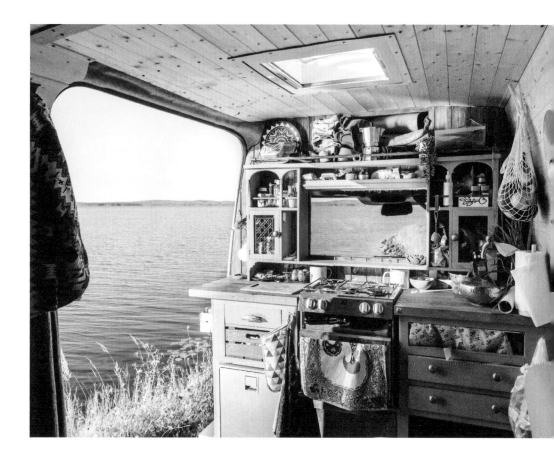

prevented a short trip through Europe from ever ending and encouraged many others to follow in their footsteps.

Travelling with a pet doesn't stop The Indie Projects from visiting incredible locations and living life on the road, either. As the true stars of the show, Ginjey and Furrnando's locations are monitored by GPS trackers on their collars, though Theo and Bee have both had to climb trees to coax them back down to earth on several occasions. With a custom-made litterbox (sporting a door shaped like a cat), a comfortable sleeping platform above the driver's cab, and plenty of treats, Ginjey and Furrnando's nomadic lifestyle is one of sweet, cat-napping luxury.

In 2018, The Indie Projects bought a plot of land in rural Portugal and set about converting an old barn into a rustic country home. They get supplies via Poste Restante, a service whereby travellers can pick up items from any post office by adding 'Poste Restante' to the envelope, along with their name and the address of the local post office, which will hold them for collection in person, and by visiting nearby towns. They've managed to create a spectacular off-grid homestead that serves as a relaxing base camp between their many road trips to the Arctic, America and beyond.

'Top up on water whenever you can – it's astonishing how much you can go through!'

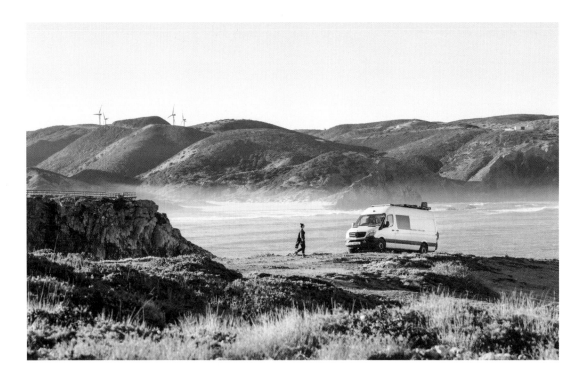

THREE ESSENTIAL ITEMS

→ Motorhome WiFi – being YouTubers, we need good internet access wherever we are

→ Solar power – endless energy (as long as the sun is shining). Nothing beats being self-sufficient

→ Hiking boots – exploring the outdoors became a big passion of ours once we started travelling extensively

MOST MEMORABLE DESTINATION

→ Lofoten Islands, Norway

→ If you like the look of the Lofoten Islands, then consider planning a road trip to:
 Vík í Mýrdal, Iceland
 Isle of Skye, Scotland
 Rhône Alpes, France

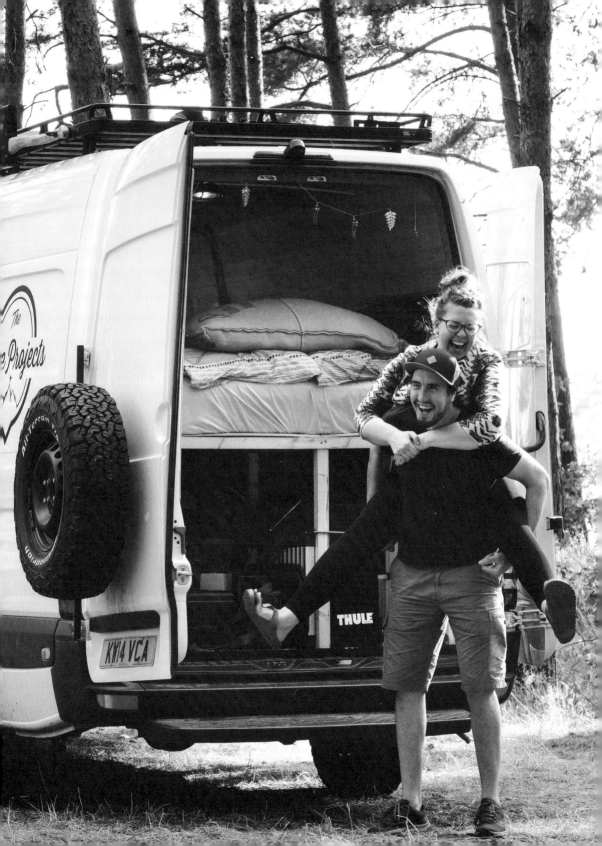

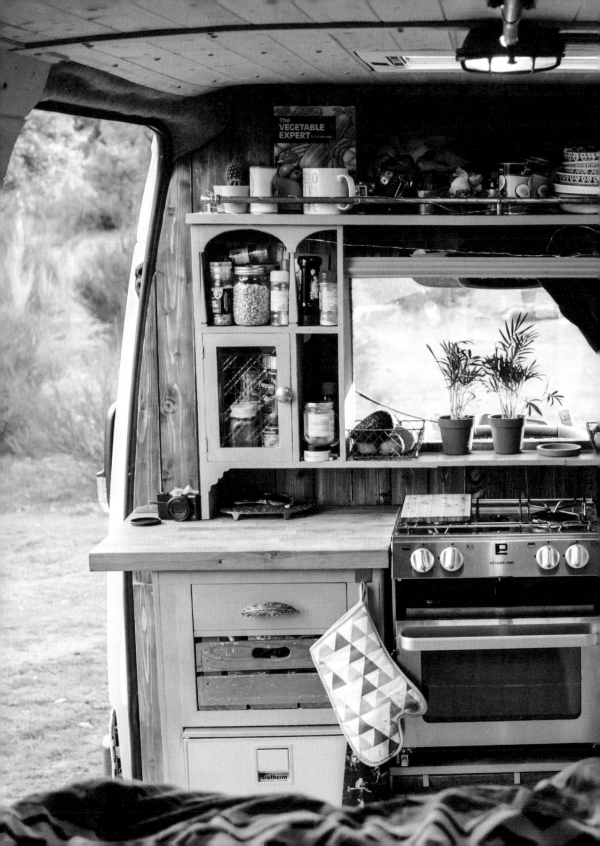

RAINBOWS ON THE ROAD

Lessons from a roadschooling family

 @rainbowsontheroad

 Bulgaria

 'Ludo' – 2013 Luton Box Van

'Ludo' the Luton Box Van is home to Carly, Laura, their daughter Agnes and Roy the dog. This travelling family have been working and living on the road since 2018 after Laura proved to her employer that she could efficiently carry out her role at a UK college remotely. Since then, Ludo has seen them safely through fifteen different countries as they document their exciting adventures through mainland Europe as 'Rainbows on the Road'.

From the sun-kissed Côte d'Azur to tranquil Turkish mountain ranges, Rainbows on the Road live, work and explore wherever the road may take them. Laura logs into her work using any internet connection she can find, usually by hotspotting from her mobile phone, and finding signal is never a struggle now that the world is so connected. Sitting at her desk inside Ludo with an ever-changing view, Laura chooses her own working pattern and creates the perfect work–life balance. She splits her working day into smaller segments in the morning and evening to make dedicated time for exploring with the family and experiencing everything that each new location has to offer.

The move into their travelling home wasn't without its moments of tension and stress, however. Converting their van while Carly and Laura worked full-time and with Agnes in education was tough, and the initial process of downsizing twinned with the need to make some big decisions about the family's future often felt daunting. But, with a focus on what life on the open road might bring, they worked hard and made their dream lifestyle a reality.

Carly and Laura roadschool their daughter Agnes, allowing her to choose her own topics and the medium in which she learns them, alongside other online curriculums for core subjects such as mathematics. Even with the whole world as her classroom, Agnes manages to avoid distractions and enjoys learning new skills and honing key interests with Carly, driven all the while by her parents' dedication to proving that anything is possible.

As a family unit, Rainbows On The Road have never been closer, and Roy the dog is never short of incredible forests and beaches to explore. In 2020, Carly and Laura bought some land in Bulgaria, where the family now has a base for Ludo and a calming and tranquil space where they help foster rescue dogs for a local charity.

Still, long-term travel drives this family, and the open road is often calling. Their fantastic tiny-home-come-trundling-office knows no bounds, as does their lust for adventure.

'Hire a van before buying one. We did this and within twenty-four hours of hiring a panel van, we knew we wanted something significantly bigger.'

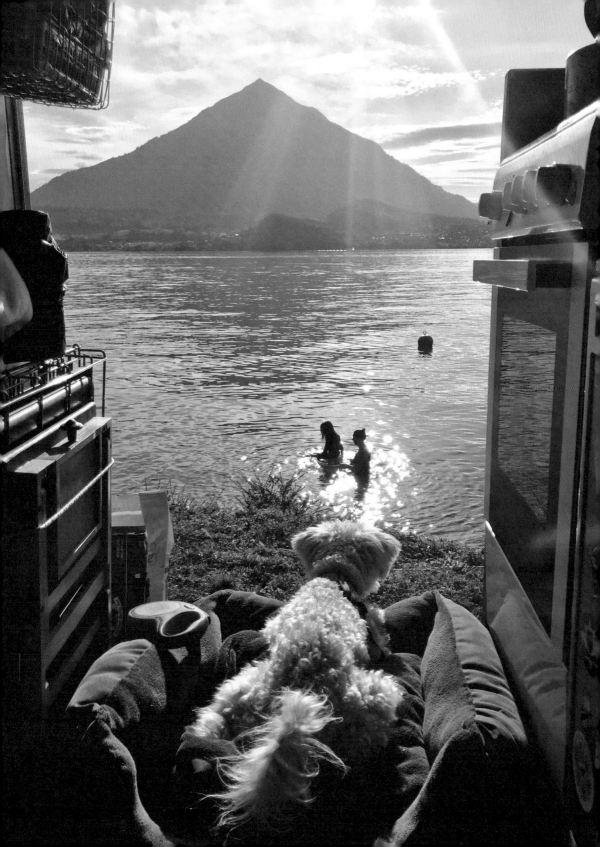

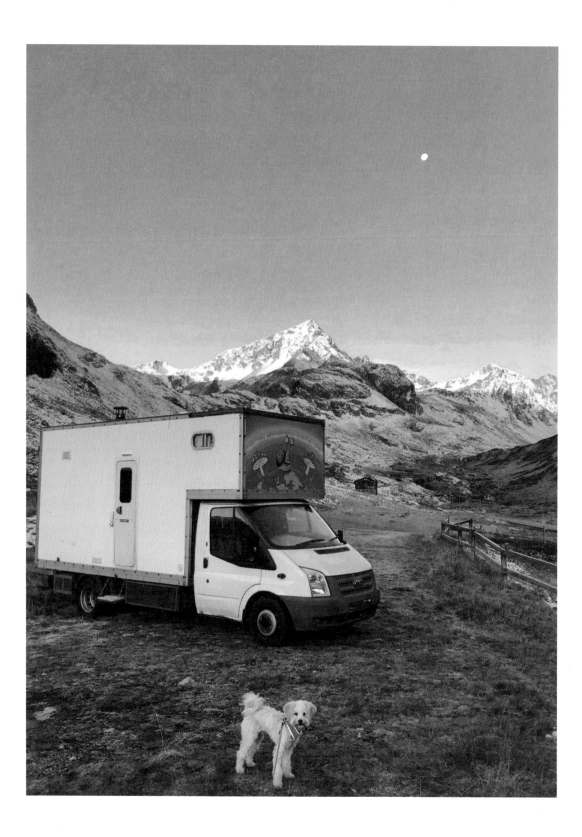

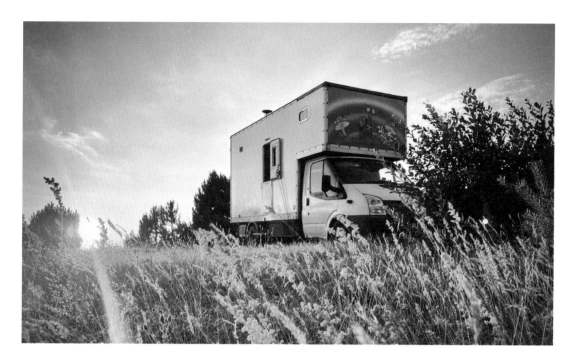

THREE ESSENTIAL ITEMS

→ The internet – we use it for work, finding park ups, roadschooling, researching local areas and it enables us to be part of the online road-life community

→ An onboard toilet – useful so we don't have to head out into nature

→ Scrubba Wash Bag – it's so easy to wash small items quickly without using a tremendous amount of water

MOST MEMORABLE DESTINATION

→ Cappadocia, Turkey – for the fascinating rock formations

→ For a taste of the stunning scenery of Cappadocia, then consider a road trip to:
 Sierra Nevada, Spain
 Antelope Canyon, Arizona
 Giant's Causeway, Ireland

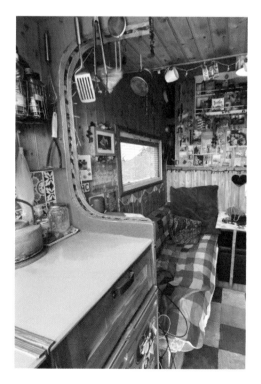

IRIE TO AURORA

Diversifying road life one mile at a time

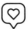 @irietoaurora

 USA

 'Irie' – 1985 VW Vanagon

Podcaster and founder of Diversify Vanlife, Noami knows a thing or two about alternative living. Together with their partner Dustin and German Shephard Amara, Noami travels full time in their 1985 VW Vanagon 'Irie', working and funding their life on the road as a digital nomad and remote entrepreneur. A self-proclaimed accidental minimalist, Noami moved from a 140 square-metre (1,500 square-foot) apartment on St. Charles Avenue, New Orleans, into 7.5 square metres (80 square-feet) of van for what was originally supposed to be a road trip to visit all of America's national parks. Five years later, Noami and Dustin are still living life on the open road with no end to their rolling adventure in sight.

Quitting their job as an environmental scientist was perhaps the scariest thing that Noami has ever done. Still, the faith that they could work it out on the road and the added bonus of Dustin keeping his job on a part-time remote basis kept their spirits alive. That admirable level of self-belief and their resourceful attitude has led to Noami pursuing and exploring their passions of writing and photography, now two of their main sources of income on the road.

As well as creating inspiring content on eco-road life and other resources for digital nomads, they host the *Nomads at the Intersections* podcast, a platform that gives diverse and often unheard voices in the road-life community a chance to tell their stories. Back in 2019, Noami created Diversify Vanlife, an organization dedicated to creating a safe space for BIPOC and other underrepresented individuals in the nomadic community.

Working beneath Irie's awning by the side of a lake or on their convertible bed-come-sofa at the kitchen table, Noami and Dustin work side by side, bouncing off each other creatively while working as a team to tackle problems. In daytime mode, the couple sit at their swing-out desk with the sliding door open, typing or recording while looking out at mountains or feeling the sea breeze on their skin. As long as they are able to access the internet by hotspotting with the aid of their signal booster, they can and often do work wherever they please. And, when it's time to put the screens away, Amara lets Noami and Dustin know by dropping some heavy hints about heading out for a walk or playing with her favourite toys.

Noami isn't one to shy away from a challenge. Creating a podcasting studio in the basking heat of Tucson, Arizona might put some people off, but this is one digital nomad who will stop at nothing on their mission to contribute to and enrich the road-life movement while championing BIPOC communities all over the globe. It's digital nomads like Noami that are helping to make the roads around the world a safer, more inclusive place for all.

'The most inspiring and empowering thing you can do to get started is to meet other people who are already doing it.'

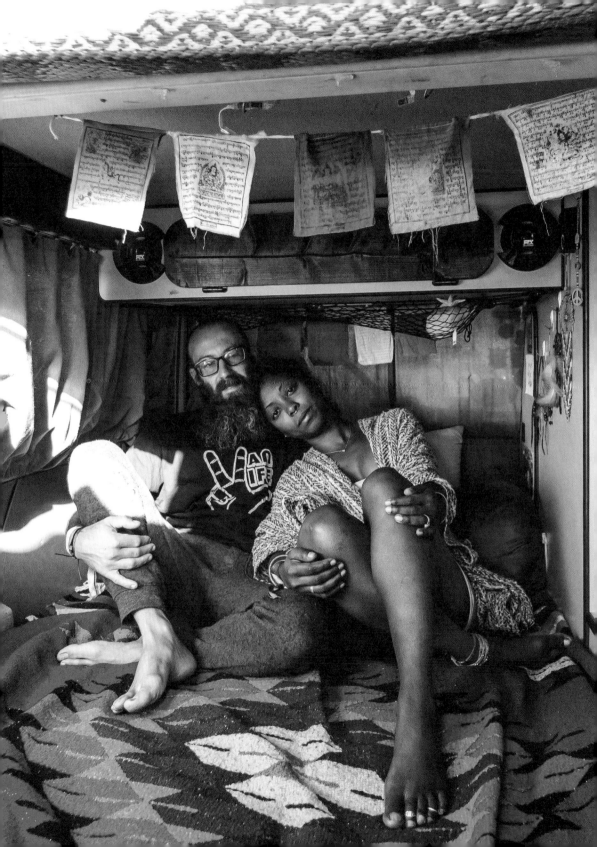

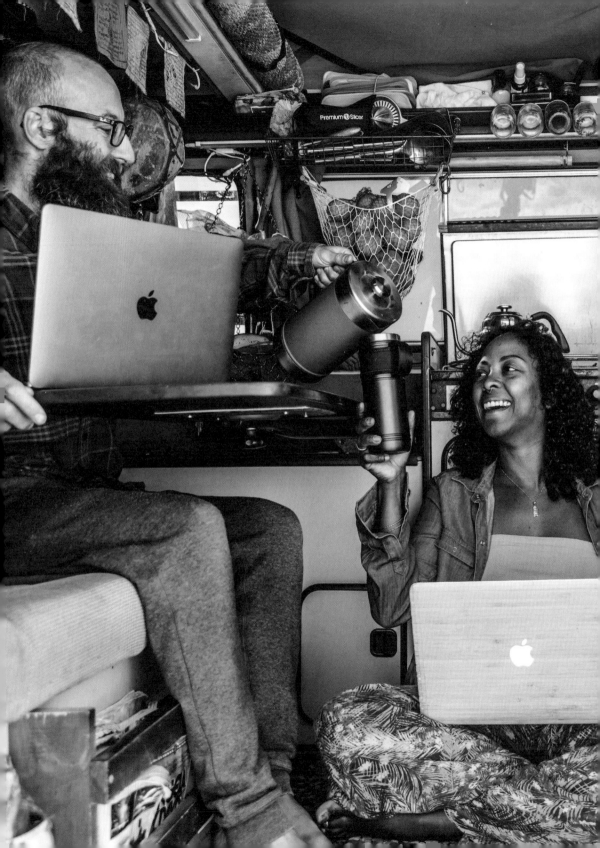

THREE ESSENTIAL ITEMS

→ My mobile phone signal booster and wireless router for WiFi

→ Bluetooth speaker – for workflow vibes

→ Yoga mat – for unwinding after or before a long day

MOST MEMORABLE DESTINATION

→ Alaska. Hands down. When Dustin and I first got on the road, our goal was a one-year road trip from New Orleans to Alaska to see the Northern Lights (hence the name Irie to Aurora). Then we would go back to our 'regular' lives. It took more than five years for us to make it to Alaska, and it was worth it!

→ If you're inspired by the beautiful sights of the Northern Lights, then why not take a look at:

 Aurora Australis, viewable from Tasmania and New Zealand's South Island

 Lake Baikal, Russia

 Zhangye Danxia Landform Geological Park, China

TREAD THE GLOBE

Attempting to visit every country after quitting the nine to five

 @treadtheglobe

 Europe

 'Trudy' – 2004 Fiat Ducato

Too often we hear about couples who never made their dreams happen, but Marianne and Chris certainly aren't one of them. The realization that life is short and meant to be enjoyed saw this courageous couple leaving everything behind and moving into their self-converted camper 'Trudy' for a round-the-world trip that has captured the hearts and minds of budding travellers across the globe. After quitting their jobs in 2018 and living off the rental of their family home, they started a YouTube channel that now funds their life on the road, financing their quest to visit every country in the world.

After a tough year in which the couple saw close friends battle with health problems, Chris and Marianne realized that they couldn't wait until retirement before travelling around the world. They sold their belongings, gave their kids the TV, said goodbye to their beloved bath, and set out on the road. Over the past three years, 'Trudy' has carried them through twenty-one countries, and they've only just scratched the surface of their expedition.

Although Chris and Marianne are now successful digital nomads, they never set out to earn a living online. What started as a means of keeping their children updated with their adventures through homemade recordings suddenly turned into a profitable venture, with viewers tuning in religiously to watch the couple's inspirational vlogs every Wednesday and Sunday. While the initial outlay for equipment was expensive (their internet connection is still their highest monthly cost), the income they bring in from content, sponsorship and selling original merchandise allows their adventure to continue exponentially, opening doors for more exciting videos and endorsements along the way.

Working from a bench seat and a swivelling captain's chair inside 'Trudy', Marianne and Chris spend long hours honing their craft, chatting to the community and planning videos for the weeks to come, usually over a glass of wine or two. Internet access isn't always easy to find, especially in remote places like Nicaragua. This means that restaurant visits or trips to hotel lobbies and cafes are often frequent, especially since working from a branded van regularly causes distractions. When conversations are flowing and a deadline is fast approaching, Marianne provides a friendly point of contact for questioning onlookers, which allows Chris to knuckle down and edit without interruptions to get their content to the masses on time.

TREAD the Globe's videos show road life in its purest form, highlighting both the ups and the downs of life as a Digital Nomad. But for Chris and Marianne, they're more than just videos. They are a record of the fantastic memories they have made together and a continual reminder that life doesn't wait for us to make our plans; it's up to us to seize every available opportunity.

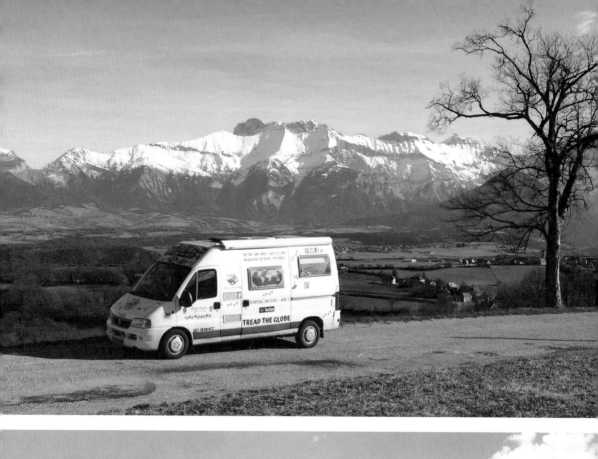

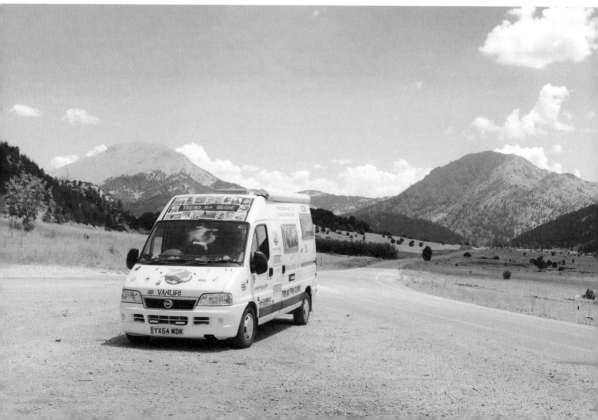

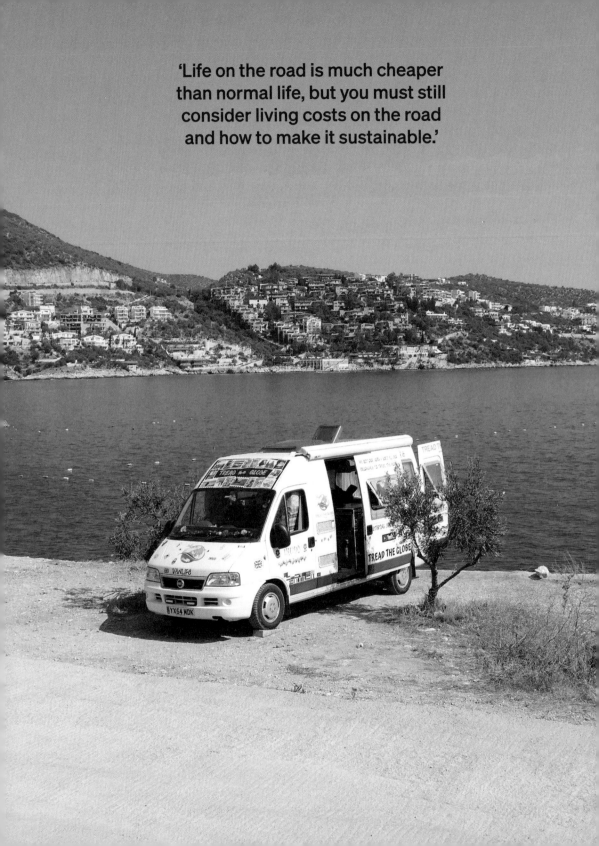

'Life on the road is much cheaper than normal life, but you must still consider living costs on the road and how to make it sustainable.'

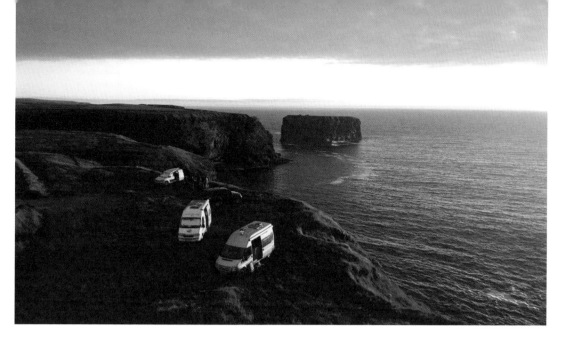

THREE ESSENTIAL ITEMS

→ Solar – having enough power is essential and can be a challenge when it's cloudy in winter and you are not driving

→ Cassette toilet and LPG (liquified petroleum gas) shower – hot water isn't necessary in the summer but makes a big difference when it's cold outside

→ LifeSaver Jerrycan – an amazing bit of water-purifying kit that allows us to safely drink any freshwater

MOST MEMORABLE DESTINATION

→ Sheep's Head, Ireland (Marianne)
 Mountains above Rize, Northern Turkey (Chris)

→ If you like the craggy cliffs of Sheep's Head or the stunning peaks above Rize, then consider planning a road trip to:
 Finisterre, Spain
 The Remarkables, New Zealand
 Duncansby Head, Scotland

BLIX & BESS

 @blixandbess

 USA

Where are we again?

 2019 RAM ProMaster

With a dream of experiencing how others live their lives and having the chance to reimagine their own, digital nomads Blix & Bess left their two-bedroom home in California and succumbed to their wanderlust back in December 2020. Working as a sales consultant for a tech firm and pursuing a career in acupuncture and Chinese medicine, Blix took their full-time job on the road and has logged in through eight different states on their journey so far. The couple's 2019 RAM ProMaster has also allowed Bess to follow her dream of becoming a travelling showgirl, providing a means of travelling to events across America where she works as a Burlesque dancer.

Road life has shown Blix & Bess that they can earn money in an entirely different way to the conventional office job life. Their travels have also given them the time to set up their own business as 'Blix & Bess', with Bess filming and editing vlogs of their journeys and their experiences as an interracial queer couple for others in the LGBTQI+ and wider community looking to follow in their footsteps. This entrepreneurial couple hopes to earn a passive income through their YouTube channel while building partnerships with brands they believe in, actively contributing to the road-life community and supporting others at the same time.

The search for the right campervan took some work, as did Bess's efforts to convince Blix to head out on an alternative living adventure. But as always, patience prevailed. The value of travel and a way to spend their money more economically was enough to convince them that it was all worth it, and after much searching, they found the

perfect campervan, newly converted with all the specifications that they would have implemented into their own build had they had the time or inclination to convert a van themselves.

Thanks to a trusty weBoost signal strengthening system, their mobile internet remains strong no matter where they park. Electricity comes from their 400 watt solar panel set up, which feeds into two lithium batteries, harnessing the suns energy for a sustainable power source on the go.

Finding a healthy working pattern has understandably proved challenging at times. Still, through mindfulness and appreciation of each other's needs, Blix & Bess have worked hard to build a creative and loving environment inside their tiny travelling home. These digital nomads are living proof that work and travel can go hand in hand, and that taking a break to go on a mountain hike is always a just reward for a job well done.

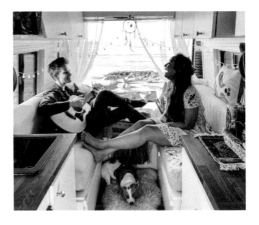

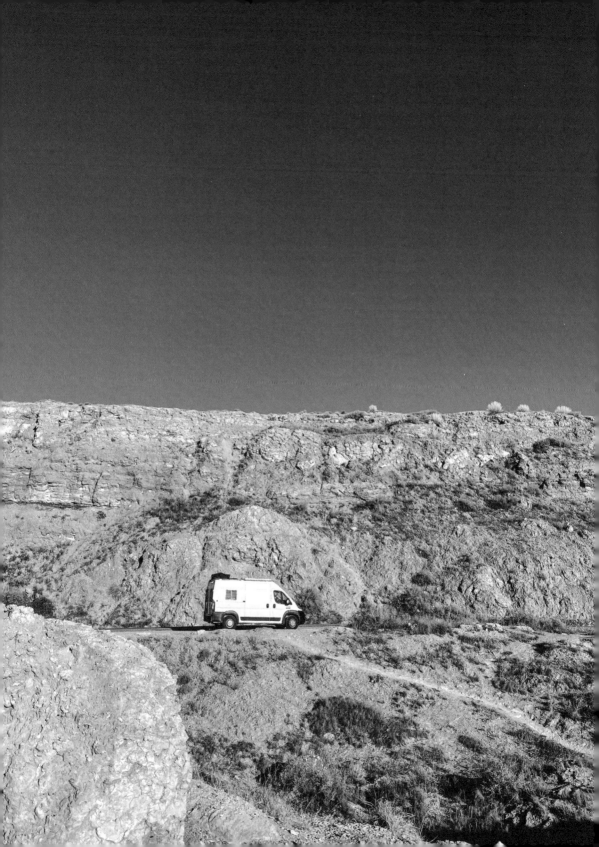

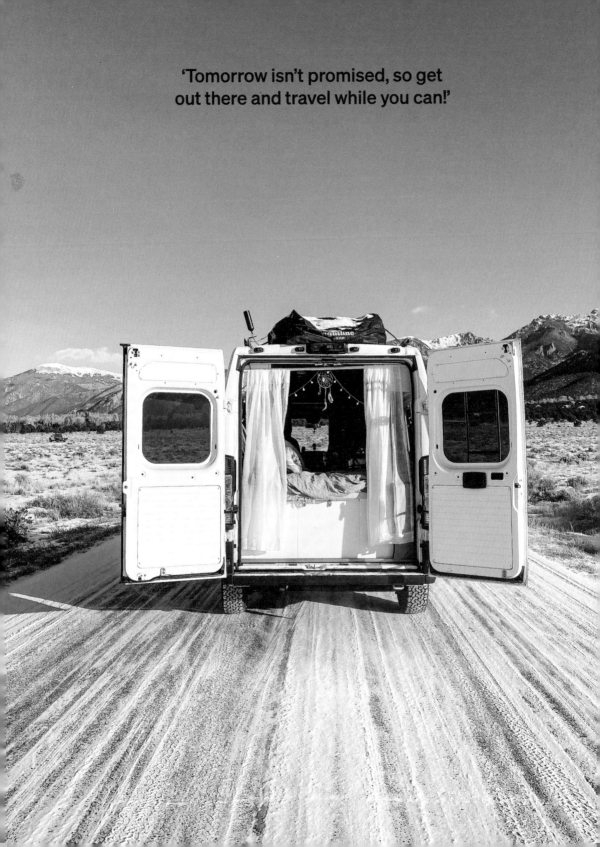

'Tomorrow isn't promised, so get out there and travel while you can!'

THREE ESSENTIAL ITEMS

→ Heater/AC/FAN

→ Composting toilet

→ Mini vacuum

MOST MEMORABLE DESTINATION

→ White Sands National Park in New Mexico, Big Bend National Park in Texas, Jupiter Beach in Florida, and New Orleans, Louisiana

→ If you like the thought of heading to fantastic National Parks or beautiful beaches, then why not consider heading to:
 The Lake District, Cumbria, UK
 Kruger National Park, South Africa
 Cala Luna, Sardinia

THE BROWN VANLIFE

Bringing exciting flavours to the outdoors

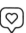 @thebrownvanlife

 Canada

 1977 Dodge B200 Tradesman

Breaking away from their expected path in order chase a nomadic lifestyle and find true happiness, Smriti and Kartik have been living and working on the road since August 2020. Together with their dog Everest, they have covered 30,000 kilometres (nearly 20,000 miles) over the space of fourteen months, travelling across the length and breadth of Canada, the United States and Mexico. At the time of writing, Smriti and Kartik are the first Indian road-life couple travelling and working in their van, paving the way for other members of the Brown community to choose their own path.

For Smriti and Kartik, their transition into road life wasn't without its difficulties, mainly explaining the concept of their new life to their parents. The predetermined actions that were expected of them having grown up in Indian households didn't sit right with them, and taking that initial step towards living life on their own terms involved some long discussions. By involving their families in the entire process and making compromises, however, they soon received their parents' blessing for their journey and even got them excited about the nuances of the building process.

Once Smriti and Kartik embarked on their new adventures, they soon realized that their brave decisions would be a precedent for other people of colour looking to follow in their footsteps. This was a chance for them to discuss many of the same social and cultural issues that other people from Indian backgrounds might well be feeling and to address them to an ever-growing audience via their Instagram channel @thebrownvanlife.

As keeping jobs was a non-negotiable topic with their respective parents, Smriti and Kartik had to discover a way to move from corporate roles and pursue careers as freelancers. Now with successful IT and digital marketing positions, this travelling couple can put in a full day's work and still be finished by lunchtime, ready to enjoy the beautiful places that they park up at on their travels. By budgeting and balancing expenses such as fuel (gas) and groceries, they have enough money left over to donate to the local charities and NPO's they connect with in each new location.

Despite travelling to new places, Smriti and Kartik always take a piece of India with them thanks to their love of cooking. While many road lifers may plump for simple meals on the go, these food lovers can often be found introducing new cuisines to people who gather at their sliding door, all tempted by the aromas of fresh spices and traditional cooking. The Brown Vanlife are bringing Indian flavours to the outdoors and opening up new possibilities for thousands of budding travellers in all communities across the globe, proving that while breaking from the mould may be tough, it isn't impossible.

'Be the trailblazers – we need more people of South Asian backgrounds out here bringing familiarity to this space.'

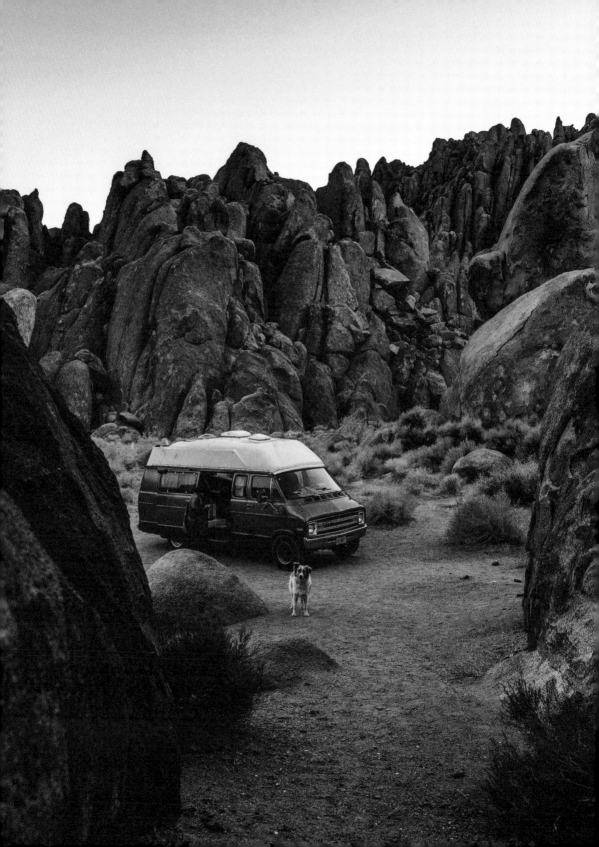

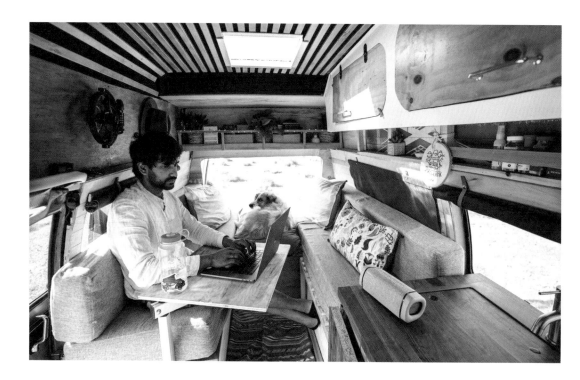

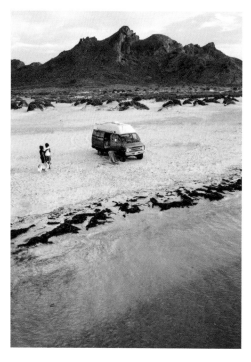

THREE ESSENTIAL ITEMS

→ Spices/pantry

→ Our custom mattress and comforter (duvet)

→ Camera equipment and laptops

MOST MEMORABLE DESTINATION

→ Todos Santos was very peaceful because we made friends for the first time since our journey started during the COVID-19 pandemic. Having social interaction again after seven months kept everyone/us feeling safe and secure

→ If you like the sound of Todos Santos and the relaxing sights of Baja California, then why not consider planning a road trip to:
 Golden Sand Beach, Shandong, China
 Nā Pali Coast, Kauai, Hawaii
 Kaş, Turkey

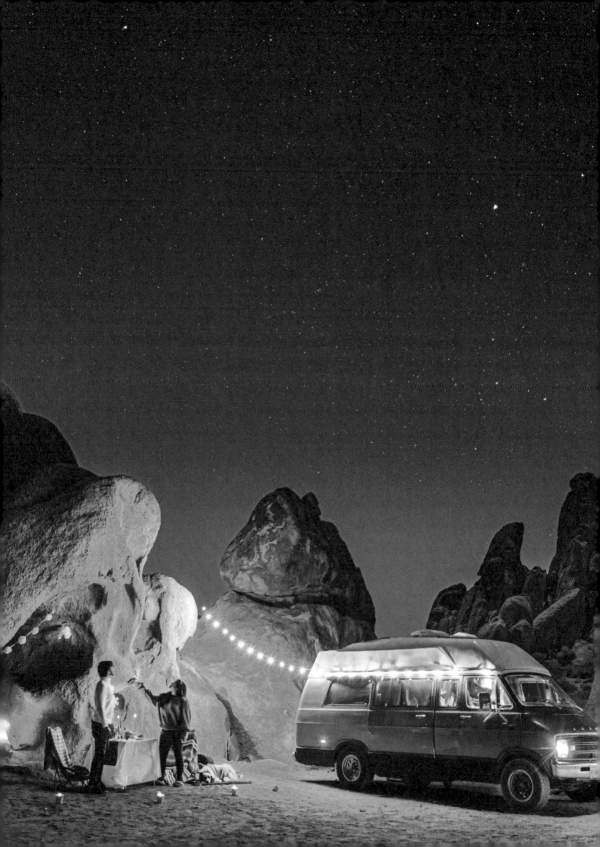

HOW TO BECOME
A DIGITAL NOMAD

1. COLLATE
YOUR WORK

Whether it's pictures of your handmade garments or a website for your music, it's essential to collate your work together so that potential clients/customers/businesses can see what it is you do.

2. EMAIL, EMAIL, EMAIL

Find businesses in your line of expertise and prove that you're the best at what you do. Write a free article, design them a new logo or create a jingle that drags their company into this century.

4. START A BLOG

Adverts on your content generate income from each person that visits your site. Write about something you're passionate about, set up a website for a niche audience, or just create inspiring content about travelling the world.

3. CREATE A SOCIAL PRESENCE

Upload engaging content on YouTube, create stunning images of your woodcraft on the road and get your work in front of a captive target audience and make money.

5. PRACTICE PATIENCE

Rome wasn't built in a day, and neither will your new business be. Establishing yourself as a freelancer takes time, so don't give up at the first hurdle. Work hard, persevere and have fun while you're at it.

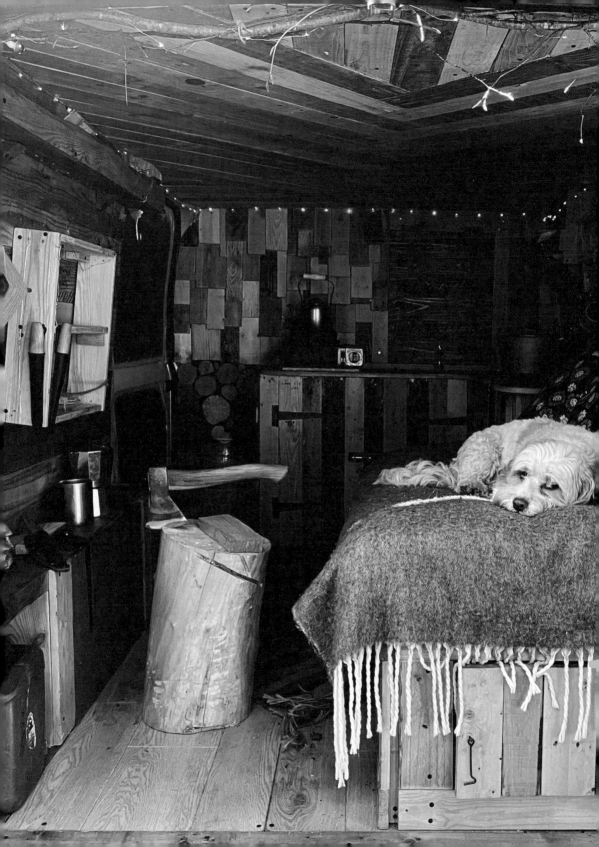

2

WEEKEND WARRIORS

Have you ever felt that tangible excitement as the clock counts down the remaining seconds of your working week, knowing that in less than an hour, you'll be on the open road and on your way to complete and utter freedom?

It sounds like you might just be a weekend warrior!

Road life doesn't have to be just about full-time travel. For many, balancing a thriving career or the joys of family life with a love of the great outdoors gives them the best of both worlds. It's that means of escape into unknown territories, the freedom to let loose and pursue hobbies and passions while savouring every second of their free time that makes this way of life so appealing.

For some, weekend or part-time road life provides a chance to let loose and unapologetically be themselves, while for others, it's a means of dipping their toes into the road-life movement to see if the lifestyle is for them.

Whatever the reason, the noble art of the weekend warrior is one that brings great rewards to those patient people who work tirelessly through the week. Whether you're looking for a means of leaving the office or just leaving the house, our next contributors have some great tips on how to jump into part-time road life and what it means to be a Weekend Warrior!

WHEELCHAIR AND WANDERLUST

Advocating motorhome accessibility

 @wheelchairand-wanderlust

 UK

 2005 VW Crafter

After a honeymoon exploring the delights of Alaska and Canada, Jade and Dave caught the road-life bug and have never looked back. They've spent the ensuing years travelling through Europe and the UK, proving to the world that road life is possible for anyone, be they disabled or able bodied. As well as exploring the beautiful New Forest and the local Shropshire Hills on weekends, Jade and Dave are challenging the motorhome industry to become more accessible, working with converters and pioneers of the road-life movement to open up more travel possibilities for wheelchair users.

Jade and Dave's initial foray into the world of road life began while converting a campervan for Jade to live in while studying Conservation and Biodiversity in Cornwall, England, with Jade learning all the necessary plumbing and electrical skills on the fly. And as someone who suffers daily with the pains of Fibromyalgia, the process often left Jade in tears.

But for Jade, their new home on wheels was much more than a cheap place to stay; it meant the freedom to travel with medications and accessible equipment on their own terms and at their own pace. Since then, they've moved onto a second vehicle, which now has a much more adaptive space; Dave got stuck in with the conversion to create a safe and accessible hotel-on-wheels no matter where they are in the world.

Travelling with a wheelchair on board brings up its own difficulties that other road lifers may take for granted such as finding a flat parking space so that Dave can move around effectively and avoiding rough terrain due to the underslung chair lift. Still, this adventurous couple have learned not to let anything stand in their way or grind them down, including continuously falling over a wheelchair or almost rolling backwards out of the van door.

The couple's van has been upgraded with a lift to give Dave access to the side door. All the kitchen doors open in different ways to make them accessible from Dave's chair, along with low-level storage and electrical controls so that Dave can reach them without any trouble. Their VW Crafter is automatic, and the van itself has been adapted so that Dave can drive using a hand lever to brake and accelerate, with the foot pedals folding out of the way when not in use. With a converted wheel arch making a seat for the shower, Jade and Dave have made some clever choices and really planned their overall design, using every inch of space perfectly.

There are still days when Jade struggles and times where the stigma of travelling as a disabled person grinds Dave down, but these best friends are more than just weekend warriors; they're a team that supports each other and brings the best out of each other in every situation, challenging themselves and proving that nothing is impossible.

While Jade and Dave's story has proved inspirational for thousands of budding road lifers across the globe, they see it as just everyday living. Call them humble, but their work is already helping more and more people with disabilities to challenge limited ideas of what they are capable of and to break old-fashioned stereotypes. Life is what you make it, and Jade and Dave are making memories that will last a lifetime.

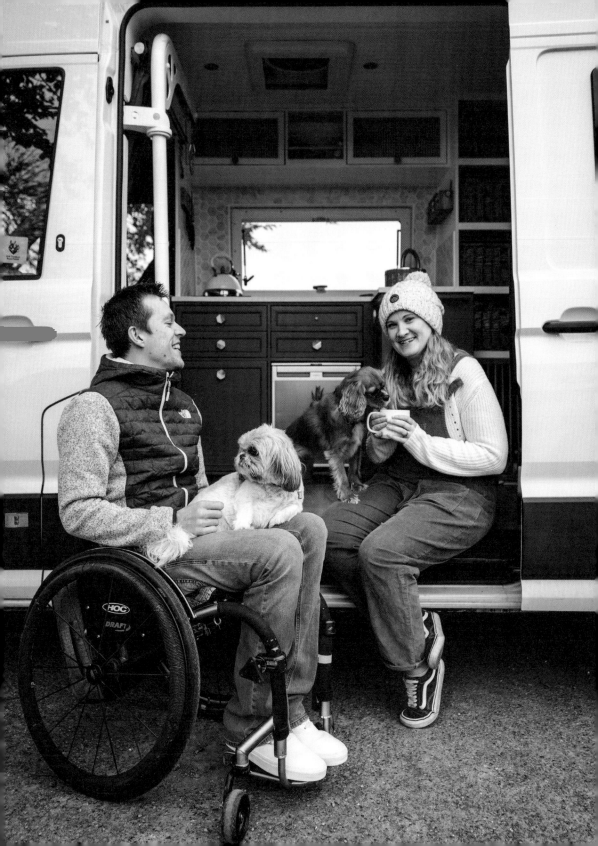

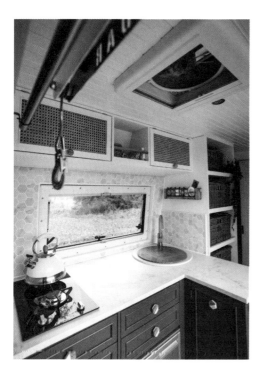

THREE ESSENTIAL ITEMS

→ A good water bottle

→ Fly screens on the windows – it's so nice to have the windows open in the van without being harassed by flies

→ Rechargeable compact drill – because a van conversion is NEVER finished

MOST MEMORABLE DESTINATION

→ Bardenas Reales in Spain – most of our road-life journey has been through COVID, but we're looking forward to exploring further afield

→ Love the sandstone vistas of Bardenas Reales? Why not take a trip to:
> Death Valley, California
> Kata Tjuta, Australia
> Meteora, Greece

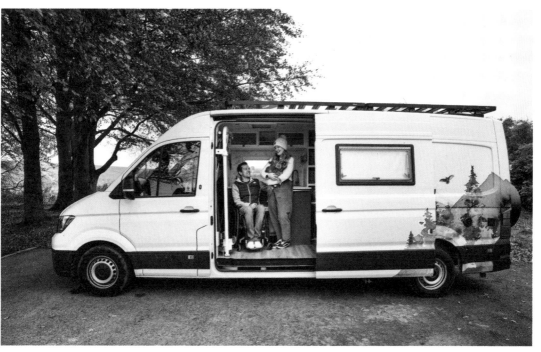

SHOT WITH GLASS

Capturing Canada and dreaming of a nomadic life

 @shotwithglass

 Canada

 2020 Ford Transit

Photography enthusiasts Mel and Ryan opted out of a conventional honeymoon and embarked on a remote tour of New Zealand by campervan, spending their first days as a married couple exploring remote places that would otherwise be inaccessible on package holiday tours. What followed was a yearning to find other countries that championed the road-life movement, a continuous adventure that saw them yearning for a nomadic lifestyle. They've just made their first leap into the road-life movement by building the van they've always dreamed of, hitting the road religiously every weekend instead of once a year, and documenting their travels on Instagram as @shotwithglass.

Mel and Ryan balance their careers and their travels, proving that being driven doesn't stop people from getting behind the wheel and driving away for some much-needed R&R come Friday evening. They work long hours, so taking off in their campervan provides a therapeutic practice that encourages them to leave their stresses and worries on the doorstep and to set aside time to concentrate on each other without distractions.

Planning plays an important part of Mel and Ryan's weekend trips as they seek out new and exciting places that they and their pups can call home, if only for a short time. The Pacific Northwest certainly isn't short of beautiful scenery as the couple's ever-growing Instagram following proves. Their 2020 Ford Transit has all of the mod-cons necessary for off-grid living including rugged suspension, a sturdy safari rack that houses their solar panels and provides a place for rooftop storage, and 300Ah (amp hours) of battery power for all their electrical needs. These practical features twinned with homely soft furnishings, a high roof and calming textures inside the camper, make this Ford Transit as far from a conventional motorhome as you could possibly get. Who said living in the wilderness has to be uncomfortable?

Many road lifers have a difference of opinion when it comes to a fixed bed versus a rock-n-roll setup, but the garage space that Mel and Ryan factored into their build by having a static sleeping platform has proved invaluable. They keep everything from skis and paddleboards to their outdoor shower system tucked nicely away, ready for whatever adventures the day might bring.

For these two budding travellers, meeting new people and the spontaneous experiences that road life provides are what makes their camper so invaluable. At the moment, their lifestyle and circumstances mean that full-time travel is still a little way off, but that doesn't stop Mel and Ryan from thinking to the future. They're comfortable giving their dogs a great life travelling through Canada and the USA, seeing (and smelling) all of the wonders that are right on their travelling doorstep. With a fantastic friendship group tagging along for the ride and new memories hidden around every corner, their weekend road life adventures provide an escape from the norm and an exciting taster of what is yet to come.

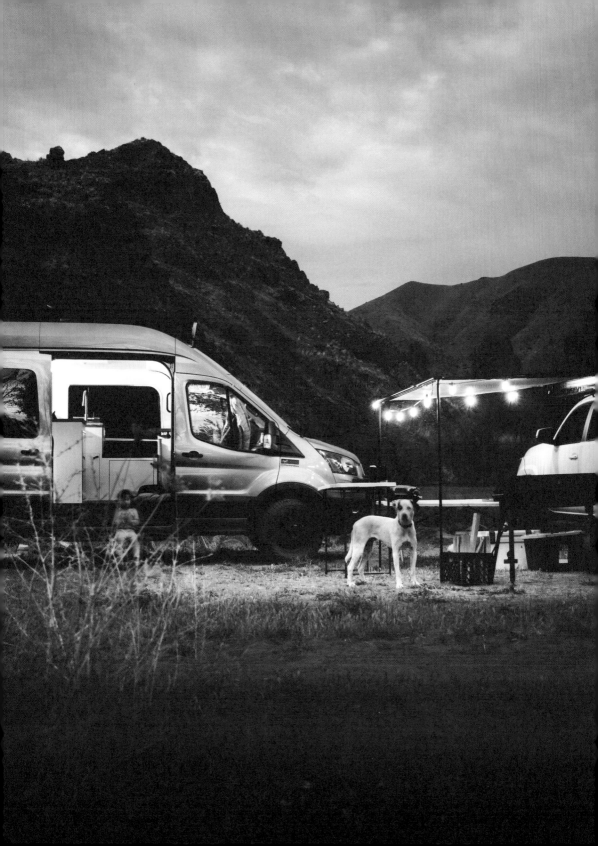

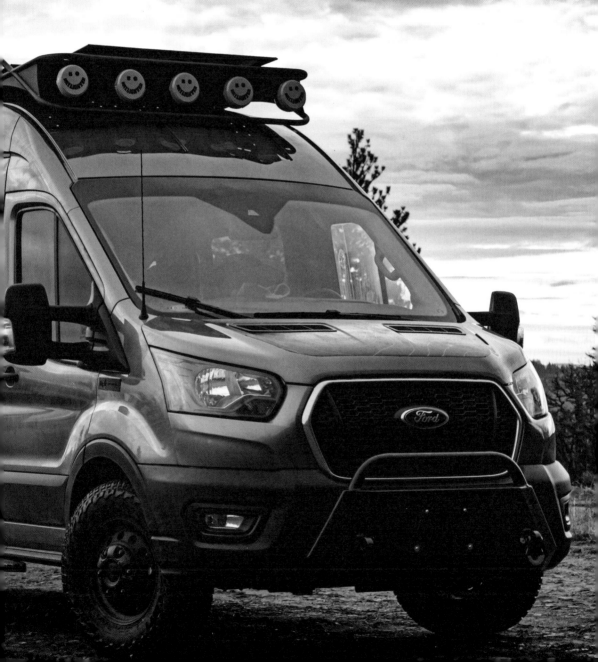

'If the prospect intrigues you, dip your toe in! Maybe you end up embracing it full time or maybe you don't. Either way is great if it leads to self-discovery.'

THREE ESSENTIAL ITEMS

→ Coffee

→ More coffee

→ Our dogs

MOST MEMORABLE DESTINATION

→ Controversially, our favourite part is often the drive. Good music, open road and the anticipation of 'getting there' is unbeatable

→ If you're keen to get behind the wheel and share Mel and Ryan's love for the open road, then consider these amazing road trips:
 The Atlantic Road, Norway
 Great Ocean Road, Australia
 Stelvio Pass, Italy

DAN HANDLEY

Take nothing but photos, leave nothing but footprints

 @thewoodlandcarver

 UK

 2013 Ford Transit

Very few campervans look as truly original and bespoke as Dan's self-converted Ford Transit. He turned a grubby, tired work van into a stunning tiny home at the start of 2021, creating a rustic wood cabin on wheels using reclaimed wood and recycled materials to chime with his love of all things handmade. Dan estimates that around 90 per cent of his interior build is made from reclaimed materials, making this camper one of the greenest rides on the road. Alongside living the boat life in his full-time floating home, Dan complements his off-grid adventures with stunning photography on his social media platforms at @thewoodlandcarver.

It only took a total of twenty days for Dan to complete this stunning custom camper, and that's all while learning on the go. The most time-consuming challenge was dismantling, cleaning, sanding and then oiling all the pallets he collected for the build, and using freely acquired materials such as floor tiles found in a skip certainly helped to keep conversion costs down to an incredible sum of just £500 (nearly $700).

While not a van builder by trade, Dan used his extensive knowledge of following an alternative lifestyle and his skills with wood to build a composting toilet, kitchen counter and a pull-out bed. His water system comprises copper piping and a foot pump hooked up to two 40-litre (around 10 US gallon) barrels, another trick he learned from his time cruising the canals on his narrowboat. The build might be simple in design, but its everything that Dan, his partner Sophie, and their dog could ever need.

While Dan has always found boat life to be relaxing and carefree, his new road life allows him to travel to places much further afield and into the wilderness, away from the well-trodden towpath outside his window. He spends a lot of time in Scotland, parking among pine trees and beside lochs, relishing being so close to nature amid the natural materials that he uses for his trade. His simple setup means he lives as basically as possible, something that Dan finds incredibly refreshing.

Without the distractions of a TV and plugs to charge up laptops or other tech, Dan embraces a minimalistic lifestyle in the outdoors, removing all clutter, stress and many of life's responsibilities. Cooking hearty meals on a one-hob burner and cherishing good company and special moments in some of the most fantastic places in the UK, Dan is making the kind of memories that many of us dream of, and the adventures aren't stopping any time soon. With his eyes set on European travel next, this rolling log cabin is soon set to wow budding road lifers all over the globe.

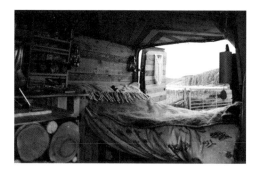

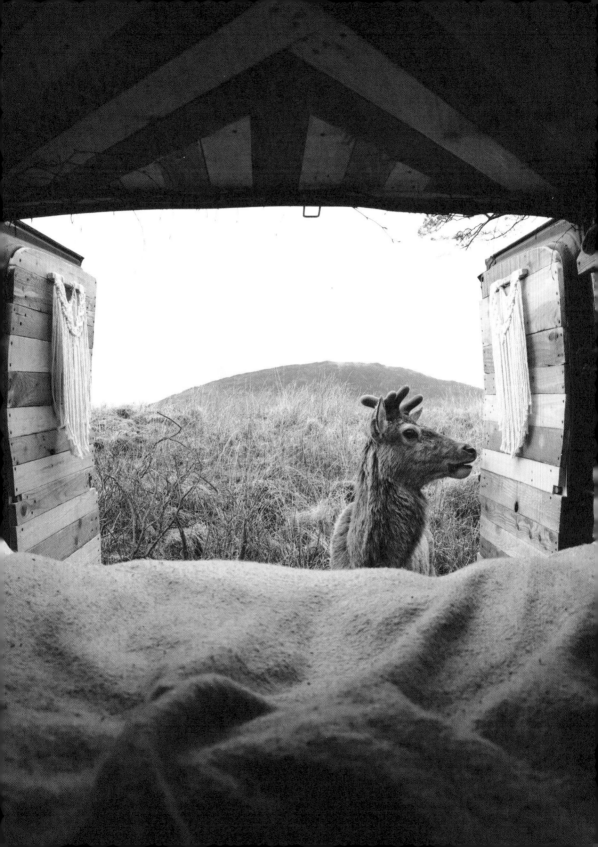

'It's pretty easy to find reclaimed materials. You'll find a lot of building works and businesses are constantly having materials brought in on pallets.'

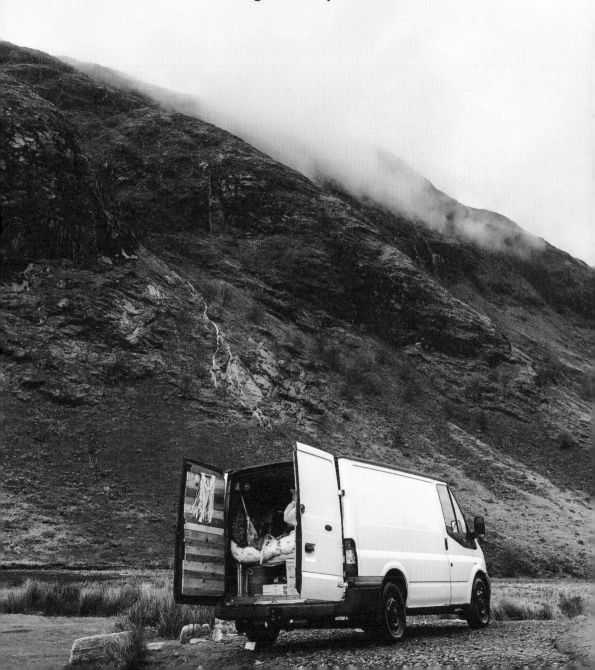

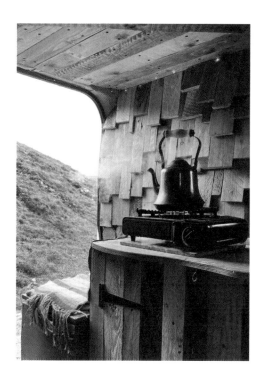

THREE ESSENTIAL ITEMS

→ My dog Twiggy

→ My girlfriend Sophie

→ My wood carving kit

MOST MEMORABLE DESTINATION

→ Scotland – the Highlands and the Cairngorms are true wildernesses at their best, full of nature and beautiful scenery

→ If you love the vast open wilderness of the Highlands and the beautiful Cairngorms, then why not consider travelling to:
 Macgillycuddy's Reeks, Ireland
 Pacific Rim National Park Reserve, British Columbia, Canada
 The Westfjords, Iceland

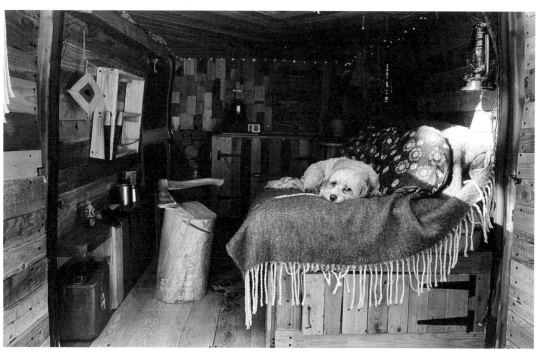

A BUS AND BEYOND

See the journey

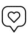 @abusandbeyond

 UK

 2016 VW Bus

Keen to head out on family adventures with their Golden Retriever Bentley, Lizzy and Shaun bought their first van for weekend adventures. Now, with a seven-year-old Bentley and a new addition to the family, this adventurous foursome gets out and about in their campervan as often as possible. They also often test state-of-the-art vehicles in conjunction with their YouTube review channel *A Bus and Beyond*. So far, they have inspired thousands of other people to take the plunge and buy a camper for travelling in, providing road-life newbies with honest and impartial advice about all the leading campervan brands and models.

Through the week, Lizzie and Shaun both work for Air Traffic Control. Their part-time road life allows them to get out into the mountains and surrounded by nature, free from the stresses of their high-pressure jobs. The value of having a home-away-from-home that the whole family (including 42 kilogram [more than 90 pound] fluffball Bentley) can feel safe and secure in, is truly priceless and travelling as a unit is incredibly important not just because of the quality time they get to spend together, but for the unrivalled memories and slower pace of life that comes with seeing the world in a camper. The A Bus and Beyond family has so far travelled to nine different countries, something that Bentley is constantly bragging about to four-legged friends he meets.

Picking the perfect park up is something of a fine art and one that Shaun and Lizzie have grown pretty good at over the years. They've travelled in small VW buses and large motorhomes more than 9-metres (30-foot) long while scoping out

free European Aires, open spaces designed for motorhomes that often have shower facilities on site. Using a combination of the global app Park4Night and their gut instincts for interesting places, this travelling family often find themselves driving along dusty roads and getting off the beaten track, choosing alternative places to holiday and meeting lots of incredible characters in the process. When it comes to travelling in Britain, Shaun and Lizzie often use campsites or the Brit Stops platform, a service that provides safe parking spots everywhere from country pubs to vineyards.

And it's not just Bentley who enjoys rolling around Britain and Europe; toddler Hervey is already beginning to show signs that this adventurous lifestyle is rubbing off on him. Lizzie and Shaun are giving him a gift that most children never get to experience: a chance to become a confident individual with a lust for travel that will one day leave him following his parents' footsteps, as well as the kind of holidays that can't be bought on the internet.

Lizzy and Shaun are becoming quite the celebrities in the alternative living world, though

'Before committing to buying a van, try one out. You will quickly learn what works for you and what doesn't.'

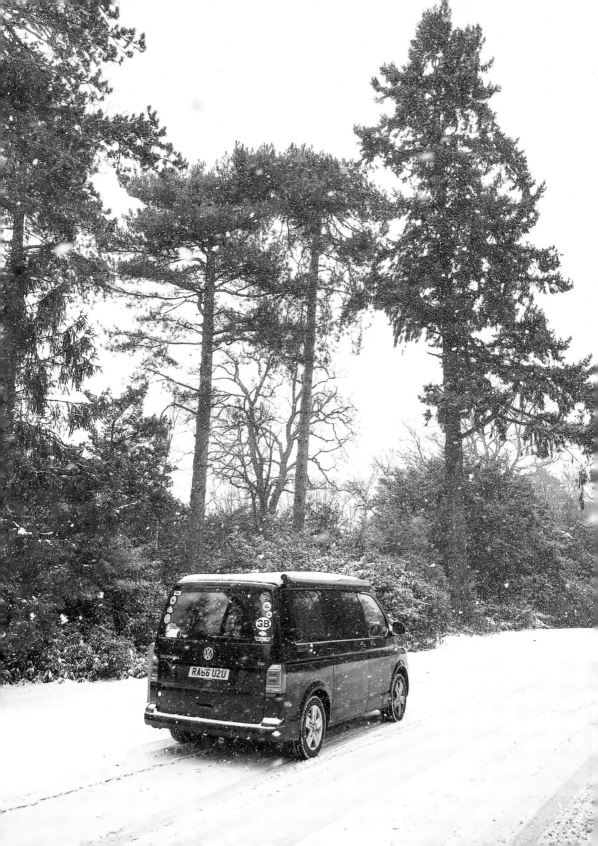

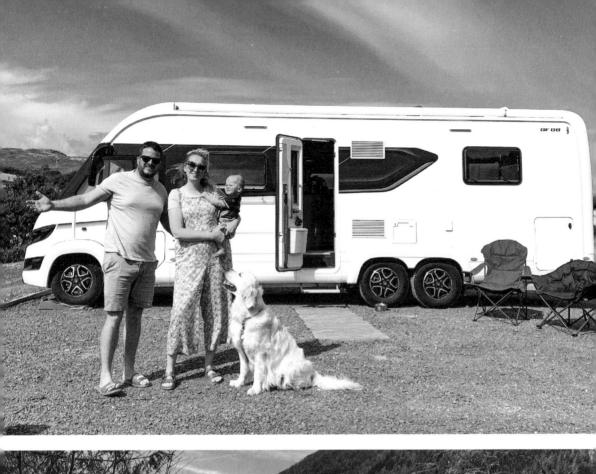

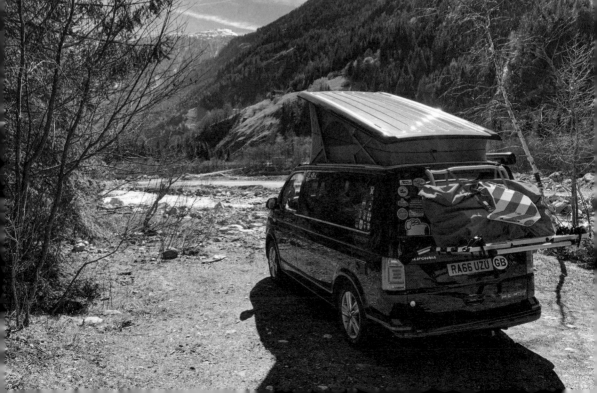

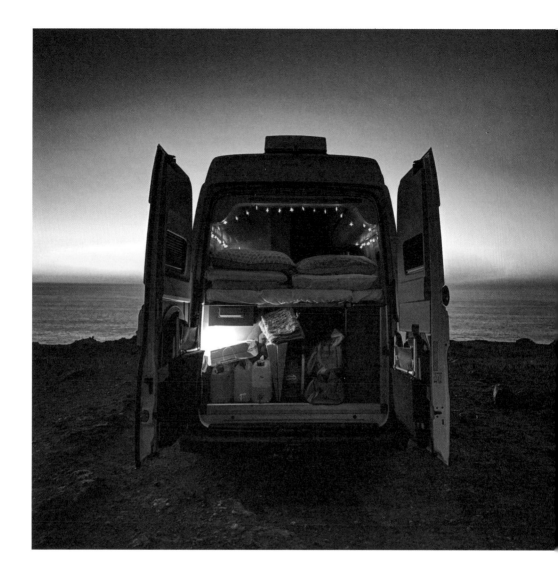

their internet popularity is something that happened quite by accident. After searching for the perfect van for Bentley to feel comfortable in, they made a deal with a VW dealership that they would only put in an order if they could test one out for a week first. They ended up loving their borrowed VW California so much that they made a review about its features so that other couples could see how spacious and comfortable it was too. The rest is history, and now Lizzy and Shaun can often be found popping up at road shows and conventions across Europe, continuing their mission to make road life simple and easy to navigate for all. They're passionate about inclusion in this thriving community and want everyone to know that they can have the adventure of a lifetime, no matter their budget or experience.

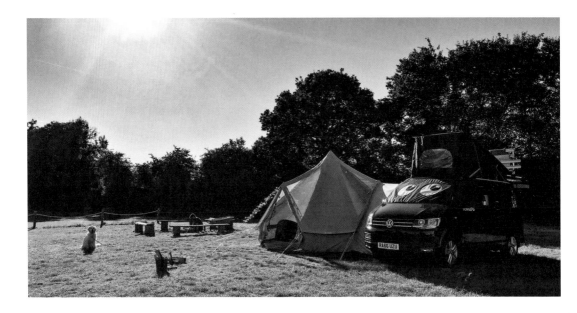

THREE ESSENTIAL ITEMS

→ Stovetop sandwich toaster (ours is a RidgeMonkey) – cooks crispy and delicious pizza on the hob

→ A nice mattress topper or thermal pop-top cover – make sure your van is warm and comfortable to sleep in

→ Fairy lights – there's nothing cosier in a van so make sure you think about some nice warm mood lighting for the evenings

MOST MEMORABLE DESTINATION

→ On our honeymoon when we drove around Europe in our VW T6 campervan and we stopped just near the Jungfrau at Lauterbrunnen in the Swiss Alps. I just stood there, awestruck, taking it all in

→ If you're a fan of the Swiss Alps, then why not consider travelling to:
El Peñon de Guatapé, Colombia
Mounte Fitz Roy, Argentina
Sugarloaf Mountain, Rio de Janeiro

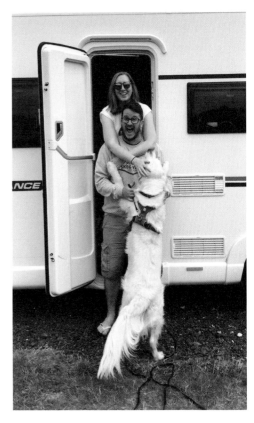

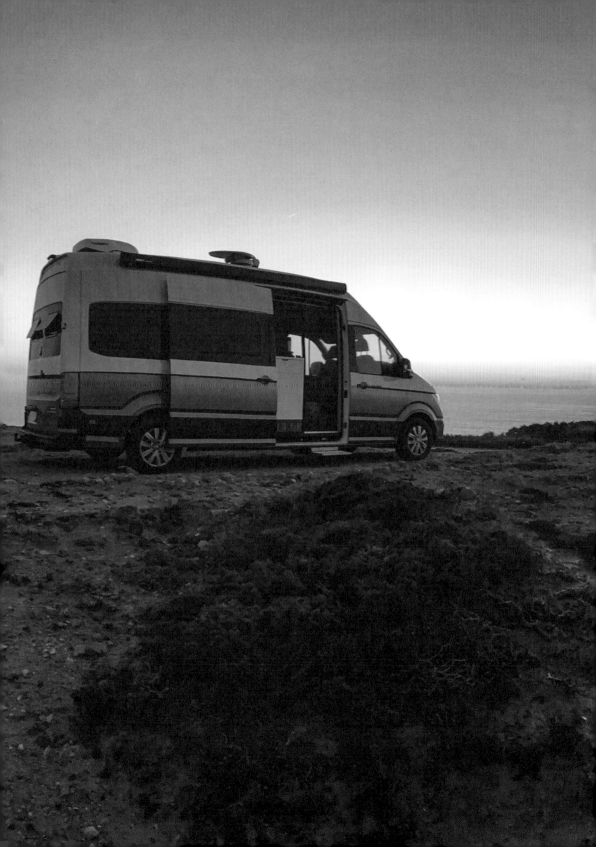

THE ADVENTURE SQUAD

 @theadventure_squad

 UK

Not all those who wander are lost

 2016 Vauxhall Vivaro

There's a general perception that having children quashes any future travel plans, but for avid adventurers Tom and Lee, adopting their son has only increased their yearning to get out and see as much as the world as possible while giving him chance to experience all the joys that life on the road has to offer. With a shared longing for spontaneous adventure at the very core of their marriage, Tom and Lee spend their weekends exploring the UK in their rustic rolling home, documenting their family outings as @theadventure_squad.

The progression to road life came as a natural stepping stone for Tom and Lee, providing a means to take their voyages to the next level. And, for a couple that sees life as one long, unravelling road, travelling along it in a trundling home-from-home that allows them to go further afield every time they leave their front door isn't just convenient, it's exciting and filled with wonder, too.

The thrill of travelling come Friday night has given Tom and Lee a taste of what life is truly about, providing a complete hiatus from both reality and society that serves as a break from the responsibilities that many of us feel bound by. Luckily, they don't have to travel far for this feeling either. Coming from Wales, they know all the best nearby spots to immerse themselves in beautiful landscapes and tranquil settings for their son to enjoy. They wild camp whenever possible but also relish the amenities of a campsite and hotels from time to time on longer trips into England and beyond, travelling as far north as Yorkshire to experience the rolling hills of the Dales.

The Adventure Squad's Vauxhall Vivaro is the perfect-sized van for weekend outings, being big enough to house the essentials; it is always stocked up for when wanderlust strikes. Tom admits to being the organizer of the family and is the brains behind many successful trips to areas of natural beauty, and being camper owners complements the couple's impulsive spirits. With the need for only a few material possessions on the open road, this family has everything that they could possibly need to feel comfortable and at peace ... each other.

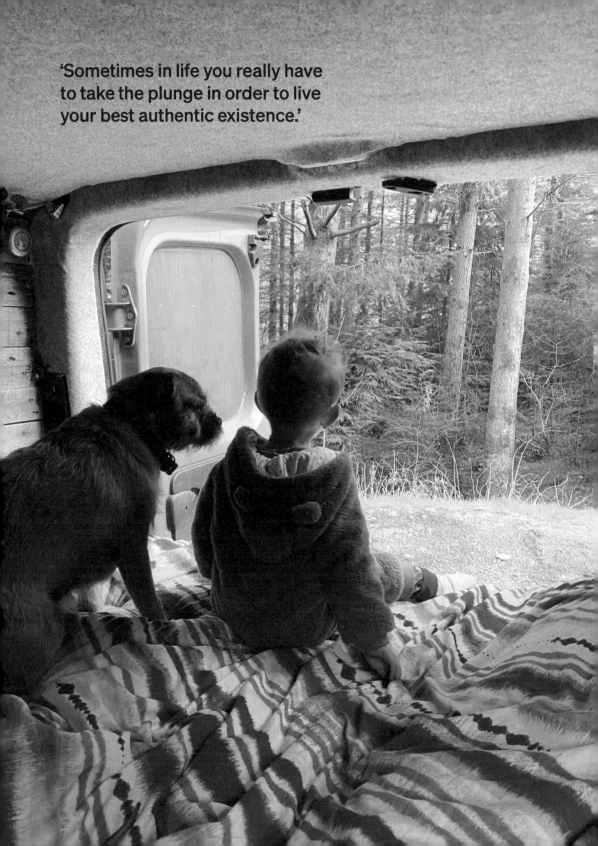

'Sometimes in life you really have to take the plunge in order to live your best authentic existence.'

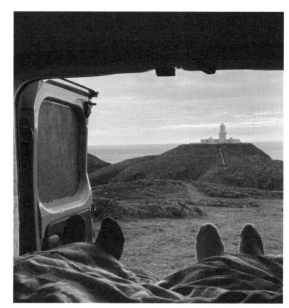

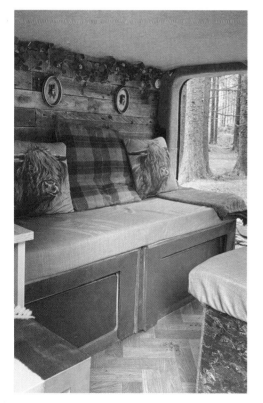

THREE ESSENTIAL ITEMS

→ Battery-operated lights

→ A kettle – there's nothing like a cup of tea made in the van, and the joy of hearing that signature whistle

→ Toilet roll – for emergency wild poos

MOST MEMORABLE DESTINATION

→ Strumble Head in Pembrokeshire, West Wales. It's a carpark that feels as though it's perched on the edge of the world, overlooking a dramatic rocky outcrop island with a lighthouse sitting atop it. We'll never forget the number of stars in the sky that night

→ If you like the sound of Tom and Lee's starry Pembrokeshire lighthouse, then why not take a trip to:
 Pigeon Point, California, USA
 Far de Formentor, Majorca, Spain
 Cape Espichel, Portugal

ESSENTIAL ITEMS FOR THE PERFECT WEEKEND BREAK

1. PORTABLE BLUETOOTH SPEAKER

Whether kicking back with an audiobook by the beach or playing your favourite tunes beside the barbecue, having a portable Bluetooth speaker creates the ambience to suit every occasion and helps to break the ice when meeting new travellers on the road.

2. PORTABLE SHOWER

Travelling with a portable shower creates more room inside the main body of your camper and means you don't have to carry excess water around in grey water tanks. Simply hook up a 12V shower to your van's cigarette lighter or opt for a solar shower bag that warms in the heat of the sun.

3. POWER PACK

If you want to keep your camper build to a bare minimum but still want to charge phones, cameras and drones on the go, then having a sturdy power pack is essential for keeping on the ball while off-grid. How else will you keep the camera charged up for those holiday snaps?

4. WASHBAG

If you want to pack light, then having a washbag on board for cleaning essential clothing items makes things much easier on long trips into the wild. Remember to pack eco-friendly cleaning products if using off-grid.

5. WATER BOTTLE

Reduce the amount of single-use plastic in the world while still staying hydrated. I never go anywhere without a reusable water bottle, especially when hiking to out-of-the-way places.

6. CAMPING CHAIRS

Nothing beats sitting in a comfy chair while looking up at the stars after a long day of exploring. Having a good camping chair means that you can work outside of your van or get prime position by the side of the ocean.

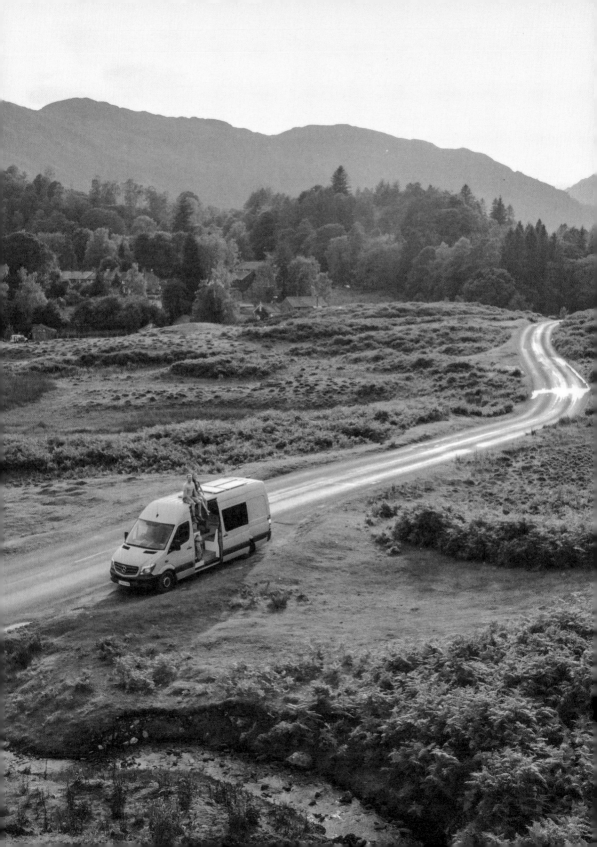

3

THRILLSEEKERS AND ADVENTURERS

That stretch of open road before you isn't just a means of getting from A to B. It's a path leading to infinite possibilities, a chance to chase adventure and conquer your fears, seeking out that action-packed life that you've secretly always dreamed of.

Road life brings the freedom to live by our own rules, breaking the status quo of 'work more, play less' and allowing us to embark on exciting expeditions doing the things that bring us joy. More importantly, it gives us the valuable gift of time, time that we can spend honing our hobbies and pursuing passions that make us feel truly alive.

Now, I know you're likely thinking: 'How can I cart around a bike or a surfboard in a trundling tiny home?'

As ever, looks can be incredibly deceiving, and our next set of road lifers have managed to build comfortable motorhomes brimming with storage solutions for every type of sport. With clever planning, a campervan can be more than just a place to lay your head at night. It can be a bike repair station, a climber's rope and helm or simply just a place to wash down after a long hike in the wilderness.

It's time to unleash your true potential. Who knows; you might just surprise yourself!

75 VIBES

Surfing sunseekers seeking life's simple pleasures

 @_75vibes

 Australia

 'Stella' – 1975 VW Kombi

Travel photographers and adventure enthusiasts Jordy and Tia hit the road in a 1975 VW Kombi back in 2018, driving over 55,000 km (88,500 miles) through the stunning Australian landscape. No longer immersed with work and a busy social life, they spend their days catching up with Mother Nature, parking by the beach and hitting the ocean for a daily surf or a swim, or trekking inland to discover the hidden wonders of the outback. An outdoorsy couple with adventure in their veins, their road life allows them to fulfil their alternative living dreams, opening themselves up to endless possibilities and never reaching for tomorrow or dwelling on the past, but living entirely in the moment.

Jordy and Tia's VW Kombi 'Stella' is a striking camper that has caught the eye of thousands of followers on the couple's Instagram page. Still, the vintage look comes at a price, and they have both had to learn about maintaining their classic bus the hard way, stepping out of their comfort zones and getting their hands dirty to keep their trusty old girl chugging along. Before embarking on each road trip, Jordy and Tia work through a tick list to make sure that 'Stella' is ready for the journey. Tyre pressure, fuel lines and the timing belt are checked regularly, as is the oil level in their air-cooled engine.

Security has always been a big concern for Jordy and Tia, especially while driving such an iconic vehicle to remote places. They always travel with a steering lock and a wheel clamp to ensure their home on wheels is still there when they return from hikes or long swims, and they've also added

locks to their fuel cap and engine bay for extra peace of mind. Luckily, the road-life community is filled with kind-hearted souls eager to offer advice on local areas, and Jordy and Tia haven't run into any trouble yet. Heads turn and friendly conversations flow wherever their adventures take them, the aura of the hippy era bringing joy and good vibes to everyone they pass.

Jordy and Tia have so far spent four blissful years enjoying the beauty of Australia in peace and harmony, and their journey is far from over. With the freedom to wake up in a new place every day and no concrete plans on the horizon, they are content to simply explore and make priceless memories. They know that travelling in 'Stella' doesn't always make for the most glamorous of lives, but they understand more than most the rewards that come from choosing the road less travelled.

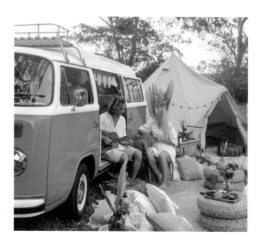

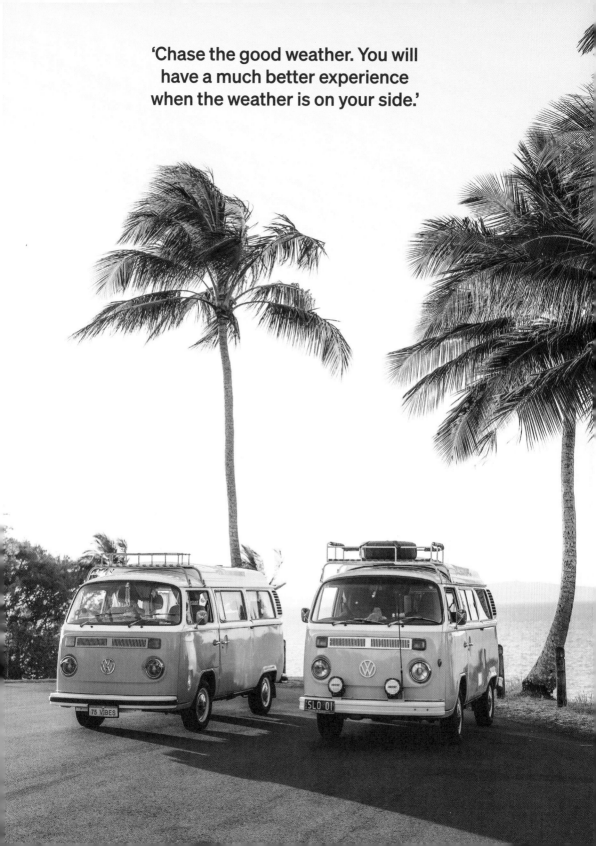

'Chase the good weather. You will have a much better experience when the weather is on your side.'

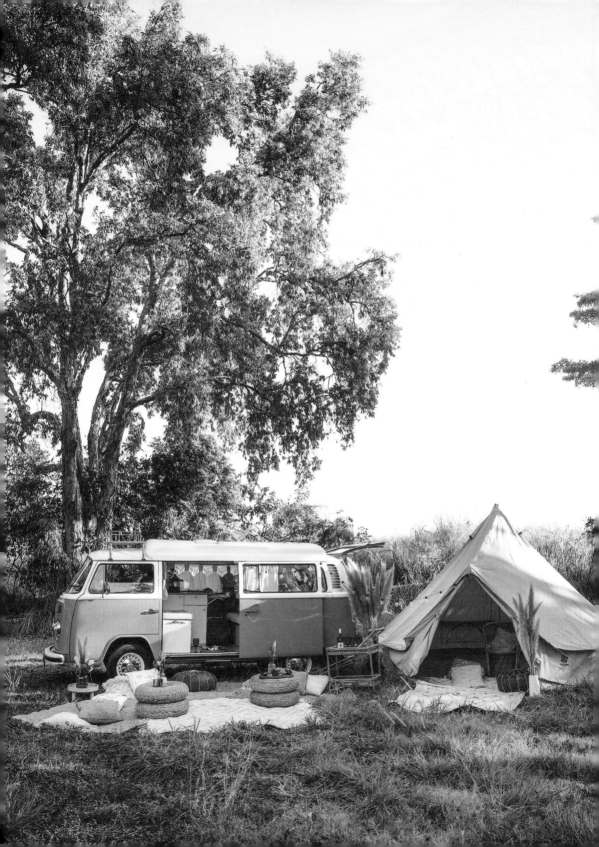

THREE ESSENTIAL ITEMS

→ Gym membership – it's more than a place to work out; it provides us with hot showers and routine on the road

→ Apps – to find free camps, water, scenic spots and more are a must. We have to mention Wikicamps because we pretty much always free camp

→ Solar panel – vital since without it, we wouldn't keep up with our power needs

MOST MEMORABLE DESTINATION

→ 9 Mile Beach, Esperance, Western Australia – we fell in love with its turquoise waters' minimal beauty and colourful tones. We could photograph there day after day

→ If you like the azure waters and soft sands of Esperance, then why not plan an adventure to:
 Stintino, Sardinia
 Hapuna Beach, Hawaii Island
 Ksamil Beach, Albania

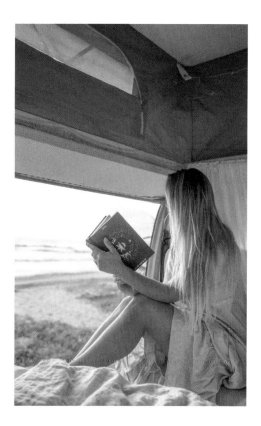

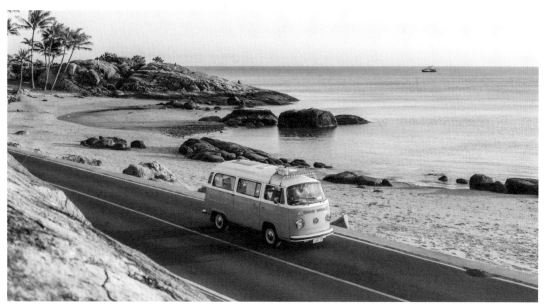

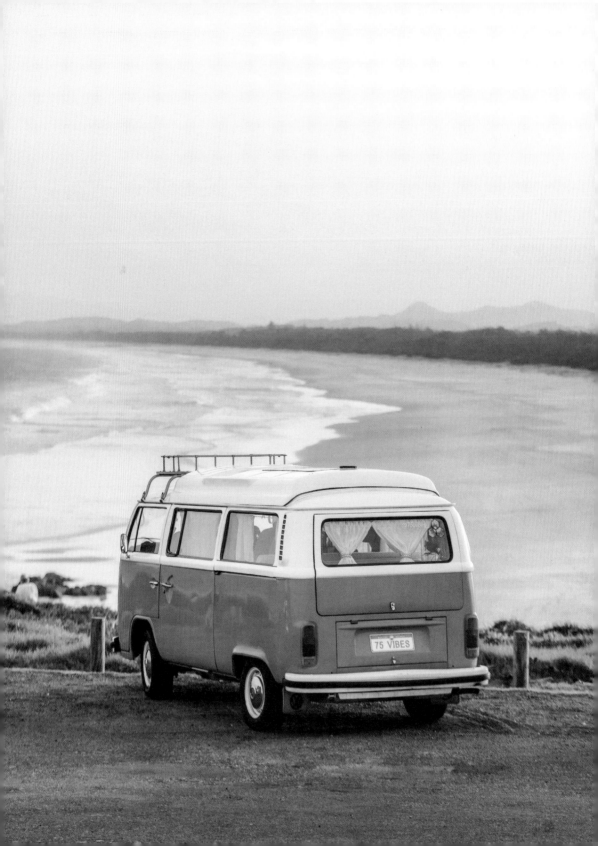

ALICIA PARRIS

Little bus, big adventures

 @bumblebus_pnw

 USA

 2003 Converted Skoolie

A converted school bus might be the last vehicle that you would expect to see ploughing its way toward snowboarding hotspots, but that's exactly how Alicia spends her days, chasing thills and dedicating time to forming lasting connections with the locations and cultures around her. Over the past two years, Alicia has spent just over £11,300 ($15,000) converting and souping up her adventure bus to cope with her intrepid lifestyle. The result: a home that both empowers and frees Alicia to live the life she wants as well as the one she needs.

Disillusioned from having nothing to show from all her hard work and a desire to revolt against the conventional working system, Alicia flipped her life on its head and made her dream home on wheels, travelling through seven states and returning to her home city of Seattle, this time without having to pay extortionate rent prices.

Alicia's skoolie is a 'dually', boasting dual wheels either side of the rear axle. With a full all-terrain tyre setup, she has no trouble reaching out-of-the-way places, even in snowy and icy conditions where other drivers could only dream of reaching. It takes a cool head to remain calm when heading out of your comfort zone, and Alicia values the importance of growing through uncomfortable situations, learning along the way and taking time to reflect once she reaches her final destination.

While many road lifers head to warmer climates for the winter, Alicia tries to get out onto the slopes at least once a week, heading out on the trail and riding her snowboard for as long as possible without the worry of having to drive back at night through a dangerous snowstorm. Having the time and scope to fill her life with positive experiences has done wonders for Alicia's mental health and wellbeing too, removing the stresses of paying expensive bills, feeling undervalued at work or living in fear of being made redundant. Her schedule, as well as the landscape outside her front door, is continuously changing, a factor that keeps Alicia in the moment and her brain sharp, ready for any eventuality.

Instead of driving to a timetable, Alicia travels on the spur of the moment, deciding how far she feels like driving each day and chatting to locals to find intriguing places to park up for the night. Living a nomadic lifestyle has not only allowed Alicia to know herself in her most basic form, but also to define her own definitions of success. She isn't governed by family expectations or the societal pressures surrounding money and material possessions. It would be fair to say that Alicia's bus isn't just carving paths through snowdrifts, it's also paving the way for others to take back control of their lives, empowering them to empower themselves.

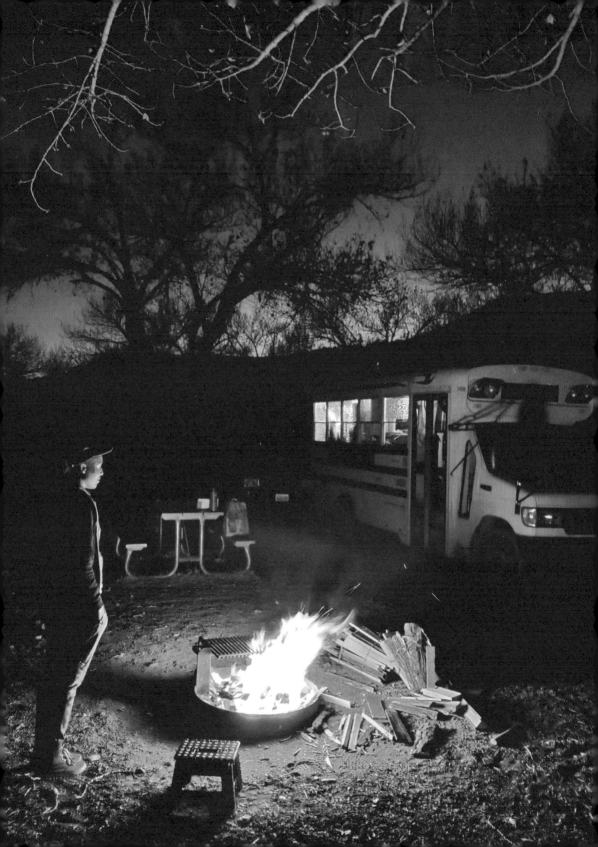

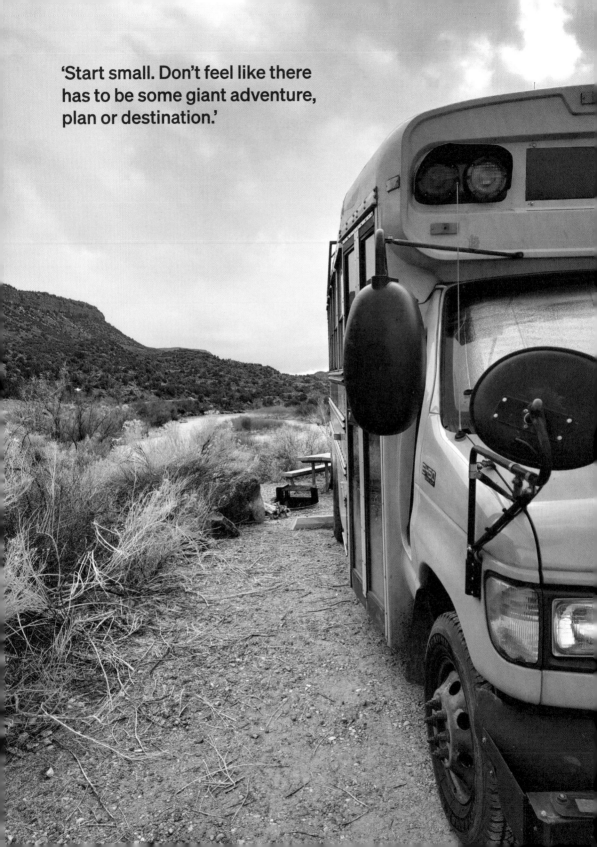

'Start small. Don't feel like there
has to be some giant adventure,
plan or destination.'

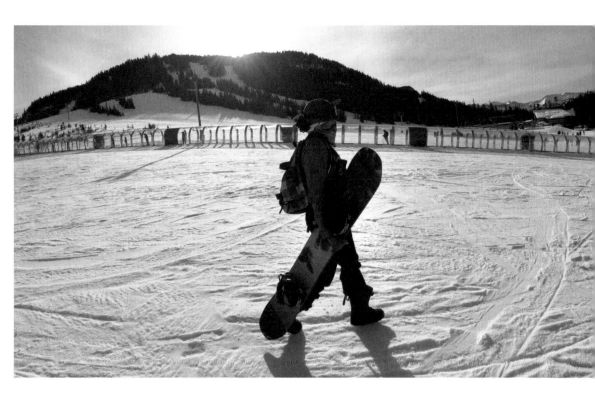

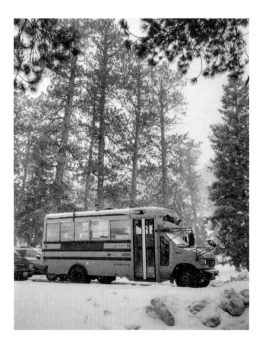

THREE ESSENTIAL ITEMS

→ My Moka pot (stovetop coffee maker)

→ Snack cabinet

→ Laptop

MOST MEMORABLE DESTINATION

→ Taos, New Mexico, USA. There is something truly magical about the desert. People there are rugged and have their own mind, but beautifully open and appreciate the arts

→ If you're a fan of Taos and the endless beauty of the desert, then take a look at:
　　Tinfou Dunes, Morocco
　　Jerome, Arizona, USA
　　Kolmanskop, Namibia

　　　　　　　　　　　　　　ALICIA PARRIS

CLIMBINGVAN

 @climbingvan

 UK

Work hard, play hard

 'Ringo' – 2013 Mercedes Sprinter

To say that road life has taken Charlie and Dale's lives to greater heights would be an understatement. This adventurous couple live for life outdoors and spend every day in stunning locations thanks to their mobile climbing home on wheels. Switching their work–life balance completely on its head, they now enjoy five-day weekends spent climbing, exploring and relaxing together in the world's most stunning locations, embracing the notion of spontaneous living and opening themselves up wholeheartedly to the thrills of full-time travel.

Charlie and Dale's dreams of converting their own motorhome first began back in 2016 when they met on a climbing trip to Northern Italy. Three years later, they took the plunge and purchased a bright yellow Mercedes Sprinter. They dedicated every available moment over the following year to decking it out into a stylish and comfortable campervan with enough storage to house all their adventurous equipment, from camping accessories to climbing ropes and more. Learning on the go and using Dale's skills as a design engineer, they completed all the work themselves, from fitting windows to hooking up gas components. They have since gone on to document their entire build process in their book, *The Van Conversion Bible*.

Every aspect of Charlie and Dale's conversion is finely tuned for both work and play. Working remotely two days a week, they make use of an adaptable living space that can either be turned into an office space with a pull-out table or a relaxing lounge area complete with a large L-shaped sofa. Plus, with an outdoor shower and an instant water heater cleverly hidden away in the back of their van, keeping clean after a long day of scaling sea cliffs or climbing mountains with a bivvy bag in hand is anything but a chore.

One of the main perks of road life is being able to change your view at a moment's notice, and 'Ringo the Sprinter' is no stranger to scouting out beautiful park-up spots throughout both the UK and Mainland Europe. Charlie and Dale wild camp wherever possible, cherishing the chance to disconnect from the stresses of modern life. They use Google Satellite View to discover out-of-the-way groves and hidden locations to park up for the night, keeping one eye on their signal strength every step of the way to make sure that they can provide help to the road-life community through their campervan conversion and off-grid energy design businesses.

Rather than just being a means of travelling to impressive destinations, however, 'Ringo' provides a comfortable base for Charlie and Dale to return to after wild swimming, hiking or just exploring the local towns and villages they pass through. They spend pretty much all their time in nature, and their slow pace of life helps them find an inner calm while still stimulating their sense of adventure. With tomorrow's mountain pass providing the backdrop for a cosy night under the stars, this adventurous couple have discovered the secret to making their work fit around their lives and not the other way around, creating a wholesome and rewarding way of life that they'll be enjoying for many years to come.

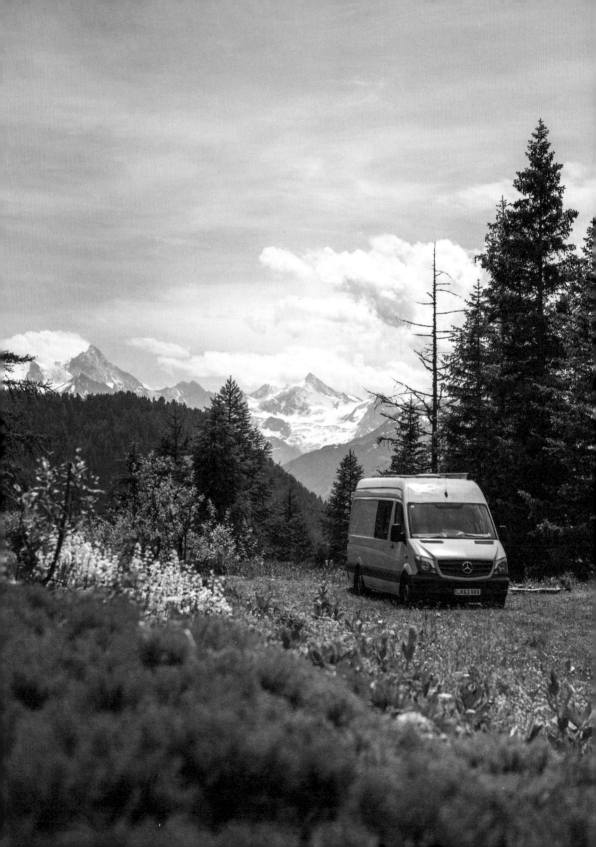

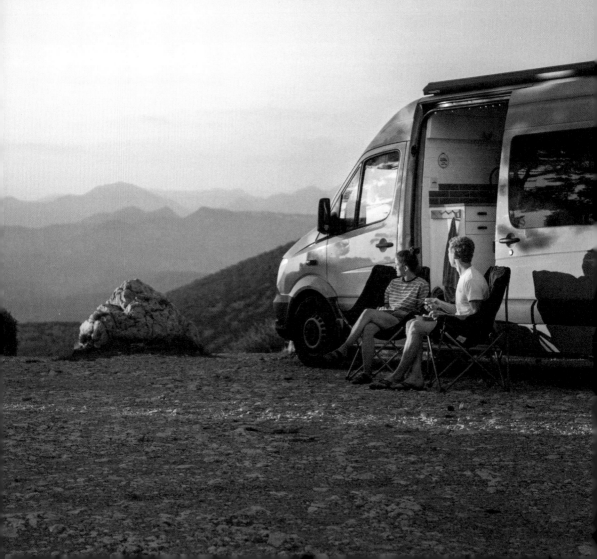

'Seek professional advice about your electrical requirements. The actual installation process itself is very simple, as long as you're installing the correct components!'

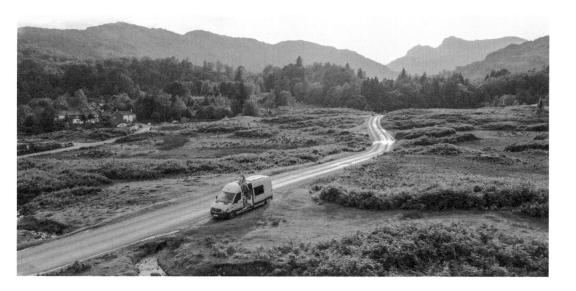

THREE ESSENTIAL ITEMS

→ Big Belfast sink – it's big enough to wash dishes, our clothes and our hair if it's too cold and rainy for our outdoor shower

→ Full-sized double bed – for comfort and for all the storage space it provides for our climbing gear

→ Off-grid electrical system – this allows us to work from wherever we travel

MOST MEMORABLE DESTINATION

→ France – from sunny river gorges with turquoise pools and pebble beaches to snow-capped mountains ripe for multi-day hikes, the landscape is so varied. Plus, it's so easy to find the most beautiful park ups! It really feels like France is set up for road life

→ If you like the relaxing pools and jaw-dropping mountains of France, then why not consider visiting:
 Pamukkale, Turkey
 Tulum, Mexico
 Termas de Laguna Verde, Chile

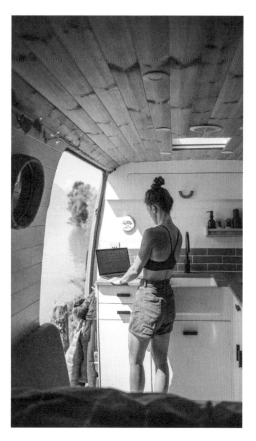

MALI MISH

 @mali.mish

 Global Travellers

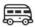 2017 4×4 Mercedes Sprinter

Compact family travelling the world

Few families have had as many adventures as Marlene, Dan and their three children. What started as a means of spending more time with their newborn back in 2008 has led to this overland family heading out on a worldwide adventure spanning a quarter of a million miles. Along with their two rescue cats, this family of five have passed through thirty-seven countries over four continents at the time of writing, living the road life full time in their 2017 4×4 Mercedes Sprinter and sharing every new experience and first step as they laugh, love and grow together.

Marlene and Dan did what so many of us are so reluctant or afraid to do: they made sacrifices, moving to a single income and downsizing to a much smaller home, this time on wheels. Over the years, they've lived in an Airstream and a pop-up Four Wheel Camper. Yet, as their family has grown, Mali Mish have surprisingly opted for smaller, more compact vehicles, favouring the ability to reach remote, off-grid areas while still being able to pass through historic villages across Europe, Asia and Africa, soaking up the local culture that ties into their structured roadschooling curriculum.

Far from feeling distanced from a 'normal life' or desperate for their own space, Marlene and Dan's children have a fantastic connection that goes beyond the usual sibling relationship. They are each other's best friends; inseparable, bonded by their shared experiences of life on the road and a closeness that can only come from exploring the world in a tiny house. They share a bed and couldn't imagine sleeping any other way, revelling

in the comfort they provide each other and continually living in anticipation of what exciting adventures tomorrow might bring.

When it came to choosing their current family home, Marlene and Dan opted for a reliable vehicle brand that has become synonymous with the road-life culture. As a world-renowned name, parts and labour for their Mercedes Sprinter are easy to come by no matter where they are in the world, which is incredibly useful for fixing or adapting aspects of a conversion on the go. And they've been working on theirs ever since, making improvements along the way such as adding a snorkel air intake for use while crossing rivers and an extended-range fuel tank for their continuous travels across the globe.

The Mali Mish team know their van inside out. They understand the nuances of tiny home living more than most, realizing early on that no one vehicle is perfect for their every need. Still, by continuously improving their home with sustainable technology, Marlene and Dan have built a comfortable road life with all the modern amenities that we turn to on a daily basis. They've used every inch of their roof space for storage, ventilation and those all-important solar panels that feed down to their lithium batteries. Unlike some campervans, they've opted for a simple plumbing set up, with removable water jugs and a cassette toilet on board for easy fill-up/emptying on the go, and their van is equipped with both a refillable propane tank and a powerful electrical setup capable of running an induction stove. They've spent years honing this current set up,

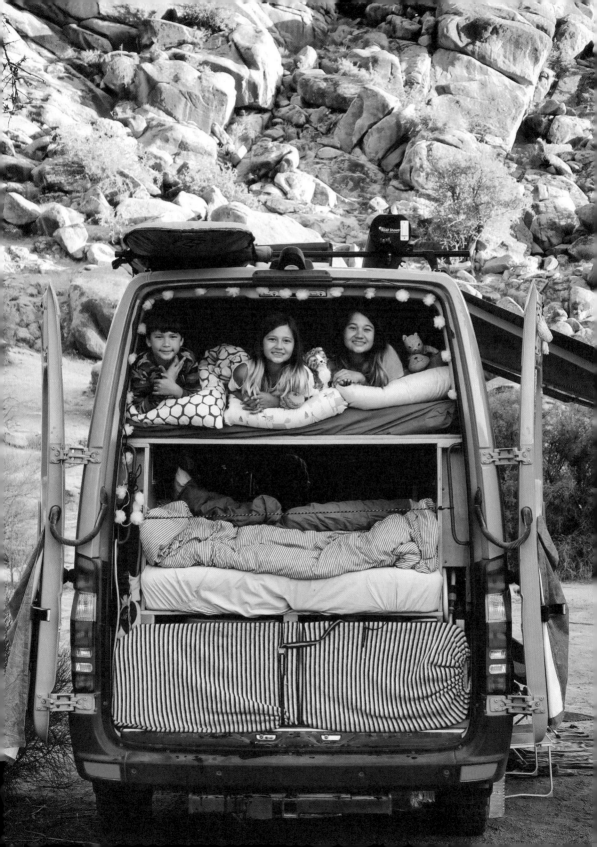

'Start with what you already have. There is no perfect vehicle, budget or time to embark on your adventure, so upgrade your gear as you find fit.'

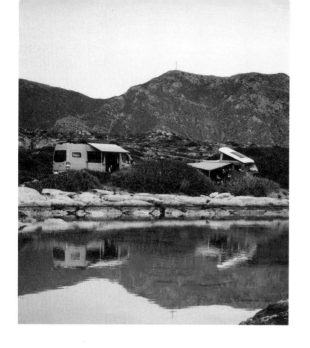

valuing a level of convenience and practicality that fits into their ever-changing lifestyles.

Marlene and Dan also understand that life on the road is rarely static. Their nomadic lifestyle sees them planning a route according to the seasons, spending winter in hotter climates near the equator and heading north for the summer to spend their days in cooler environments. This migratory pattern keeps their back garden views fresh and exciting, often providing a new vista to explore every day. They regularly meet like-minded road lifers and travellers, always parting as firm friends with the promise of meeting one-another on the road again one day. And while this intrepid family have no real idea how long they might live this life, one thing remains certain – the friends they've met and the memories they have made along the way are sure to last a lifetime.

THREE ESSENTIAL ITEMS

→ Our camera to document our life and adventures

→ Solar panels to keep the lights on

→ Our Moka stovetop coffee pot and favourite mugs

MOST MEMORABLE DESTINATION

→ Walking with crampons on Root Glacier in McCarthy, Alaska. It was our trip to Alaska that made us finally commit to travelling to places farther away. The drive to McCarthy on nearly 100 kilometres (60 miles) of gravel road made us realize we needed to downsize to a more capable vehicle

→ If you like the thought of hiking through the snowy tundra in Alaska and scaling jaw-dropping mountains, then consider planning an off-grid adventure to:
 Swiss Alps, Switzerland
 Lochnagar, Cairngorms, Scotland
 Skaftafell, Iceland

LEON PERKINS

 @leon_perkins_

 UK

Travelling to nowhere

 2003 Mercedes Sprinter

Road life often appeals to those looking for a more straightforward and calmer way of life. But for Mountain Leader and keen BMX rider Leon Perkins, his camper allows him to live an exciting lifestyle that is fast-paced and filled with adventure. With his trusty self-converted Mercedes Sprinter, Leon regularly travels to the wildest, most remote places in the UK to hike mountains, climb cliff faces and kayak down stunning rivers, as well as travelling to BMX competitions with his family beside him. Using his van for work as well as leisure, he spends his days wild camping in stunning locations, ready to take budding mountaineers on incredible expeditions along some of the UK's most impressive outdoor mountain trails.

Leon's road life first began back in 2015 when he bought an LDV Convoy. His mission was simple: to create a comfortable tiny home to travel in and sell products from his clothing range, BMX. His love of all things outdoors was to have a more significant impact on his life than even he could have predicted, however, and in time he embarked on a university course in outdoor education, paving the way for his work in nature and planting the seed of future road-life expeditions firmly in his mind.

The circle of life is constantly turning, which is why Leon's current self-converted Mercedes Sprinter camper has had three different conversions to accommodate his many passions and his growing family. A fixed double bed provides ample 'garage space' storage for bikes, climbing equipment and much more, and he's even managed to fit a single bed for his son into the main body of the build too, costing a total of just £6,000 (under $8,000) for all the work completed thus far. With an oven, a log burner and a simple solar electric set up, Leon has everything he could possibly need for his off-grid lifestyle, championing rustic aesthetics and recycled materials over a bland build devoid of character and charm.

Road life and Leon's work as a Mountain Leader certainly go hand-in-hand. His camper provides him with a means of seeking out beautiful locations, using a satellite view of his surroundings to find wild camping spots where he can relax to the sounds of birdsong and the sights of mountains, rivers and streams. Leon feels liberated and free while on the road, but safety is always at the back of his mind, especially while travelling with his family. He takes precautions to lock down his camper while out on the trail but doesn't let himself get too bogged down with worry.

For as Leon so rightly puts it, 'worry is just negative imagination', and this is one road lifer whose imagination has not only changed his way of life but enriched the lives of those around him, too.

'Just get a van, don't waste time on making it fancy, get the basics and go!'

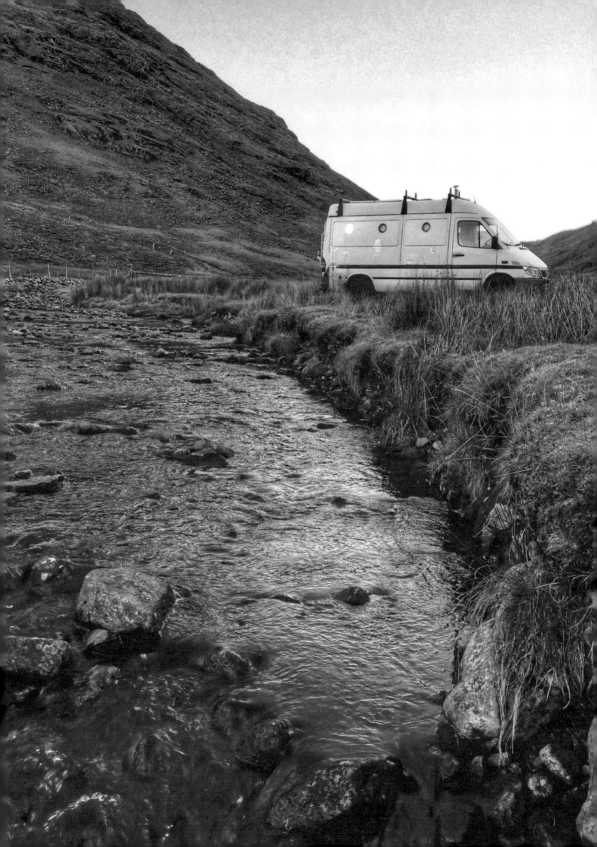

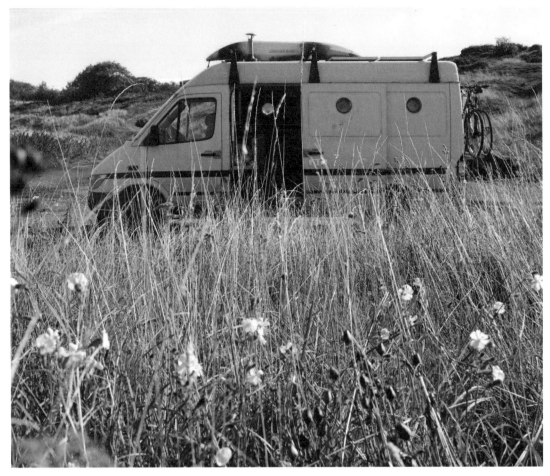

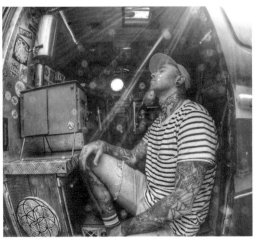

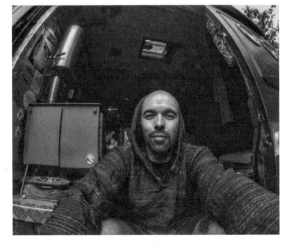

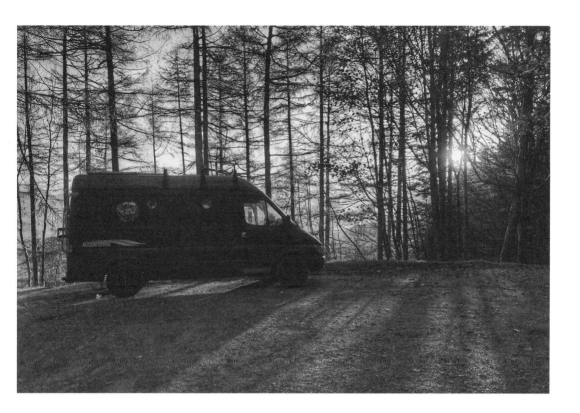

THREE ESSENTIAL ITEMS

→ Water and a sink to wash clothes and pots

→ A burner to cook meals on

→ My fixed bed

MOST MEMORABLE DESTINATION

→ I love the mountains but can't decide between Scotland, the Lake District or North Wales

→ If, like Leon, you can't get enough of mountains and lakes, then consider planning a road trip to:
 Appalachian Mountains, USA
 Bernese Highlands, Switzerland
 Drakensberg, South Africa

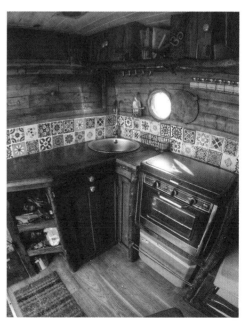

ASOBOLIFE

Living in the moment

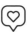 @asobolife

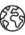 Pan America

 'Bernie' – 2018
Ford Transit

Stepping out of your comfort zone and challenging yourself to break routine can be tough, but that's exactly what Yuko and Eric did in 2018 when they bought a Ford Transit van and began planning a Pan American road trip from Canada all the way to the southernmost part of Argentina. Back in Asia at their jobs in Hong Kong and Tokyo, the way they lived was akin to 'sitting in a lukewarm bath': afraid to change their environment for fear of the cold surrounding air. After an initial eight-month van conversion period, they travelled through thirty-five national parks across the USA and Canada.

Yuko and Eric spent a lot of time boondocking (wild camping) on BLM (Bureau of Land Management) and in National Forests through North America, both areas where free camping is legal and openly permitted. A visit to Mexico followed, and the kindness and generosity they have received on their journey so far has been humbling, with both police and locals offering advice as to where to stay for free and which campsites to visit in busier areas.

For Yuko and Eric, ticking off the Americas wasn't just about immersing themselves in rich cultures and sampling exquisite cuisines, although that certainly played a large part of their travel plans. It was a chance to open their minds to a world that they knew nothing about, to explore the unknown and complete something that they never thought they could achieve in their old lives. They see every day of their road trip as both a physical and mental challenge filled with hidden wonders just waiting to be uncovered. Still, they are incredibly aware that having the freedom to explore wherever they want is both a blessing and a privilege and try to give as much back to the communities that they pass through as possible, shopping at local markets and businesses along the way.

When it comes to power, Yuko and Eric's Ford transit is equipped with a whopping 300Ah of LiFePo4 batteries and a 350 watt solar panel, which is more than enough to keep them self-sufficient wherever they travel, even on cloudy days. Still, if the weather gets bad, a split-charge relay hooked up to their starter battery provides power while they drive.

Yuko and Eric have a proposed end date to their travels of December 2023, but they're well aware that this goal might end up being pushed back, possibly indefinitely. Still, when you've experienced what this adventurous team have over the past few years, can you really blame them?

'All the worries you had before travelling in the van all sort themselves out when you're on the road.'

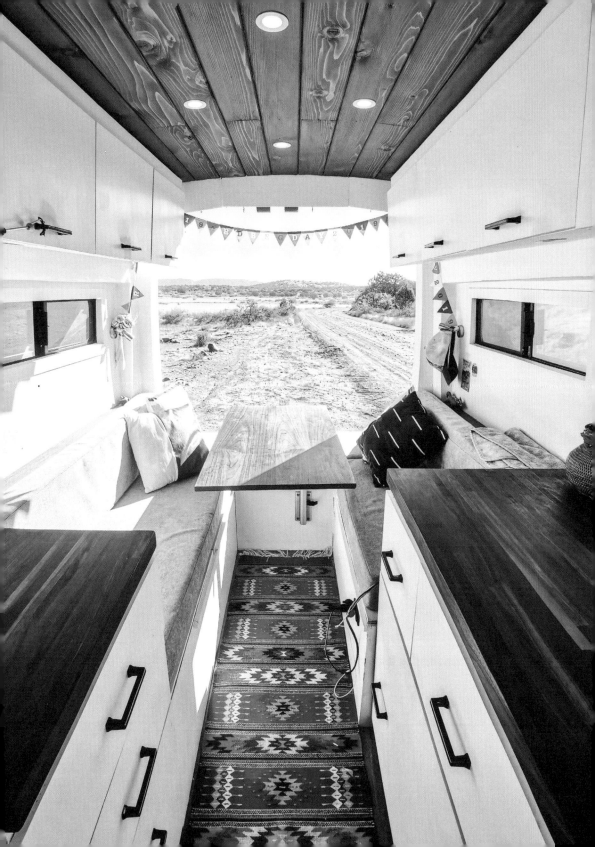

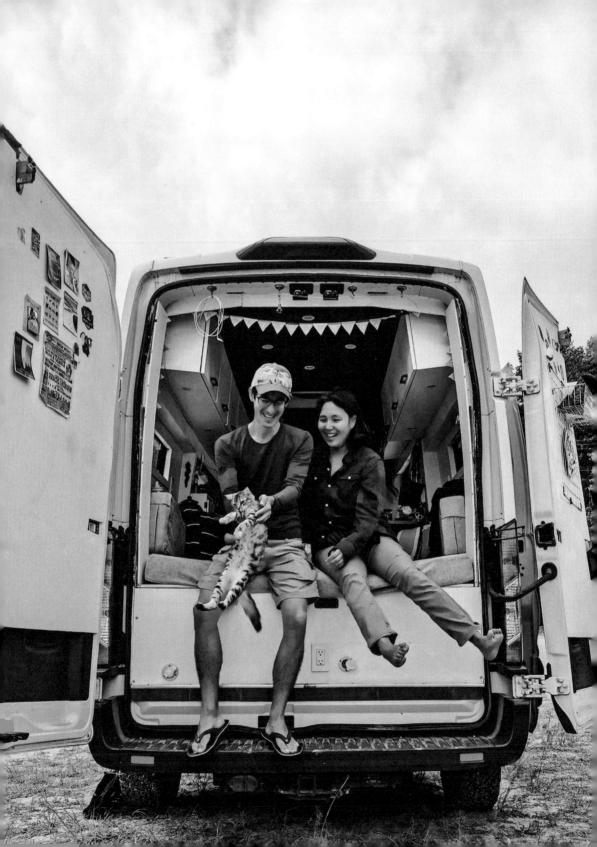

THREE ESSENTIAL ITEMS

→ Electric fridge – cooking is so important in a van that a place to keep food fresh is critical

→ Instant pot – this electric pressure cooker is amazing and helps us cook easy meals when we come back to the van

→ Our cat – we adopted a stray kitten in Guatemala. Maya, a bundle of energy, has been brought so much joy to our travels for the past five months

MOST MEMORABLE DESTINATION

→ Mexico's Copper Canyon (Barranca del Cobre). Standing over the canyon's edge and looking straight down the cliffs was an awesome sight

→ If you love the jaw-dropping valleys and the luscious greenery of Copper Canyon, then take a road trip to:
Colca Canyon, Peru
Altai Mountains, Mongolia
Verdon Gorge, France

STAYING SAFE
ON THE ROAD

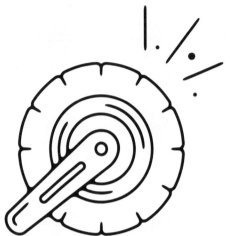

1. WHEEL CLAMP

Not only is a wheel clamp a visual deterrent, but it also physically prevents people from driving away with your camper, giving you peace of mind that your rolling home will be exactly where you left it when you return.

2. EXTERNAL LOCKS

It's always a good idea to install extra locks on the doors that lead to your living space. By fitting a master lock to your rear doors and a sliding lock on your sliding door, you make your vehicle less of a target while parking up in unknown areas.

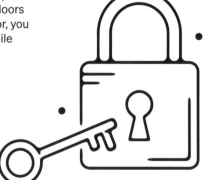

3. TRACKER

Having a tracker isn't just good for if you can't find your vehicle; it also lets other people know where you are if you run out of phone signal or get into a spot of bother. By giving a friend or family member log in details for the tracker, you can be assured that someone always knows where you are.

4. SATELLITE PHONE

If you plan on spending a lot of time out in the wilderness or backcountry where phone signal is poor, then having a satellite phone on board in case of emergencies is a great idea for staying safe on the road, and you can rest assured you can contact loved ones to let them know you are safe no matter where you are.

5. SOCIAL MEDIA

Social media may have a lot of things to answer for, but it's a very useful tool for gaining opinions about local places when searching for places to stay. Likewise, the road-life community is always available to give advice if you have mechanical problems while travelling. I've met some of my best friends this way!

6. TRUST YOUR GUT

If all else fails, always go with your gut instinct about any situation. If you don't feel comfortable in the first few seconds of arriving to a new location or scenario, then it's not going to get any better over time. There's no shame in moving on, and you'll enjoy your adventure much more if you feel safe and content.

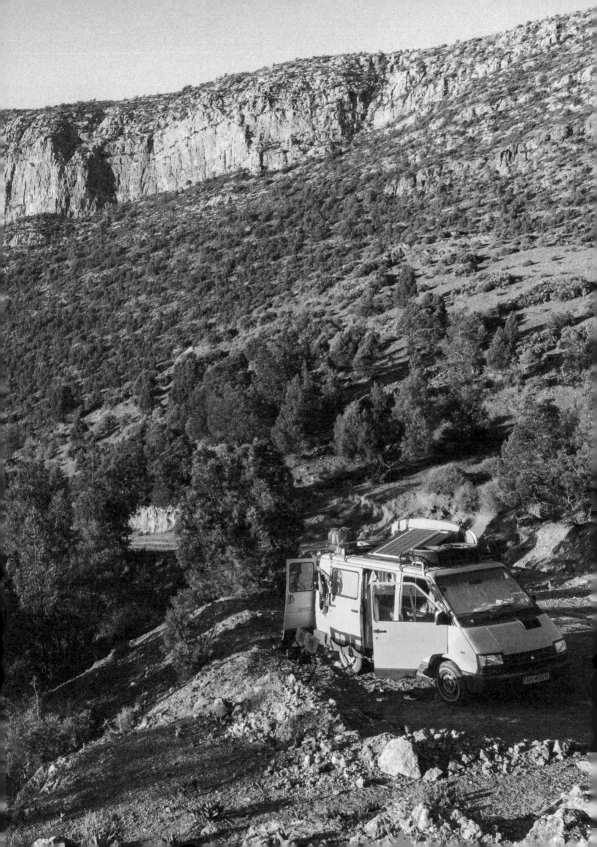

4

SHOESTRING TRAVELLERS

They say that money makes the world go round, but is it possible to travel around the world without it?

In a climate where living the dream can sometimes mean leaving everything behind, relinquishing that five-figure salary or the security of a steady job might seem foolish or downright bizarre to some. It's that leap into the unknown that holds so many of us back but travelling on a shoestring can certainly be a freeing, cleansing and life-changing process.

So how do we make that first move?

Living within our means, getting rid of all that old clutter and downsizing into a tiny travelling home makes us feel more carefree, less attached to the nine to five, capable of going anywhere at the drop of a hat.

Building a camper from scratch helps keep all of your costs in check, too, and travelling on a budget using savings or occasional income as opposed to a full-time salary pushes us away from conventional hotels and city breaks and out into the heart of nature, living in natural beauty spots with the whole world as your front garden.

See, travelling on a budget isn't as bad as you first thought!

ANNIEK AND MATTIAS

 @reehoorn

 Bulgaria

Live a little to live a lot

 1991 Nissan Traffic 4 × 4

Dutch road lifers Anniek and Mattias left their jobs in Amsterdam in favour of an old Nissan Traffic 4×4 and the open road. They strived to see the real world, not just the one advertised in city break brochures, but the costs involved with travelling the conventional way had always held them back. Keen to live their dreams sooner rather than later, they bought a bright yellow Nissan and spent €2,000 (around £1,700/$2,250) converting it into a DIY campervan, learning on the go and designing every inch to their own specifications while keeping building costs to a bare minimum along the way.

Rather than seeing tiny living as a hindrance, this adventurous couple think of their simple camper as a luxurious hotel capable of reaching remote beauty spots. Instead of visiting campsites, Anniek and Matthias use Park4Night to find wild camping park ups in secluded areas away from the hustle and bustle of the city. They shower in lakes and hot springs and clean their clothes (and Tobi the dog) in pools and rivers with eco-friendly products en route. A toilet comes in the form of a shovel and some biodegradable paper, and they clean their teeth while looking at beautiful vistas and listening to the sounds of nature. With all their belongings under (and on) one travelling roof, a comfortable bed, and the freedom to go anywhere, they genuinely want for nothing.

Even when facing breakdowns with their trusty Nissan Traffic, a small budget never stops Anniek and Mattias from continuing their adventures. The kindness of strangers always prevails, and a cup of Turkish tea and a smile can go a long way despite language barriers. There's always a discount and, more importantly, a solution to be found.

But it's not just the financial element of travelling in a van that drives Anniek and Mattias. Life in the slow lane has shown them that they don't need much to live off, and the same goes for power and consumables, too. Harnessing natural energy, cooking fresh produce and living simply has had a significant effect on Anniek and Matthias' ecological footprint as well as their bank balance. It's led to them building an off-grid tiny house in the Netherlands where they can carry on implementing the lessons that shoestring travel has taught them, heading out in their trusty camper at weekends with Tobi the dog for more exciting adventures across Europe.

Discussing their road life journey so far, Anniek and Mattias recall that:

'On our travels through Turkey, we've learned that we don't need much to be happy. We work if we need to and don't push ourselves if we have no inspiration. The minimalistic lifestyle helps us to focus on the things that we truly want in life, and it feels good to see the world from a different perspective. By living little, we live a lot!

'Our most lasting memories are made from trips to remote areas that took all our effort to arrive at. Choosing the hard way seems to pay off more often than not.'

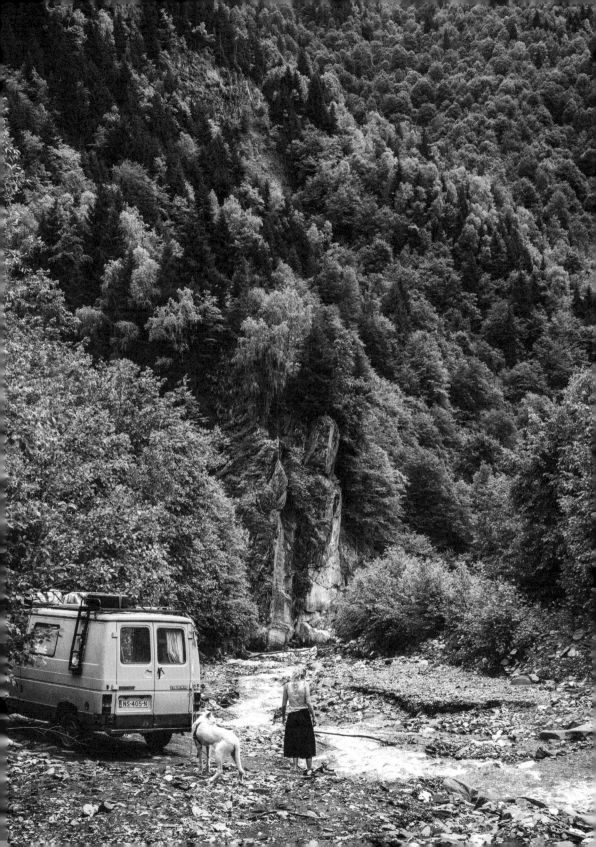

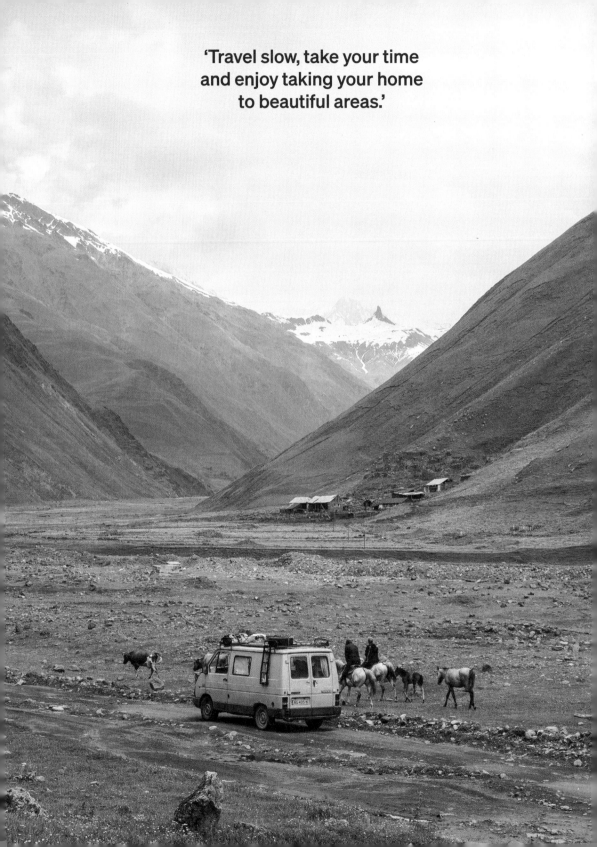

'Travel slow, take your time
and enjoy taking your home
to beautiful areas.'

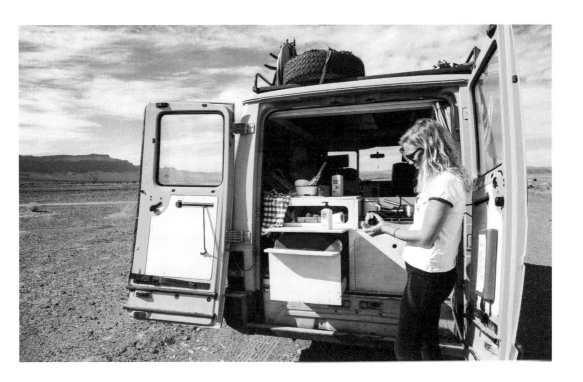

THREE ESSENTIAL ITEMS

→ Our coffee percolator – the perfect way to start the day

→ Phones – we use them a lot for apps such as Park4Night, hiking maps and Google Maps

→ Adventure footwear – hiking boots (Anniek) and running shoes (Mattias)

MOST MEMORABLE DESTINATION

→ Albania, for the history, stunning scenery and friendly people

→ If you like the stunning coastline and rural sights of Albania, then consider planning a road trip to:
Cala Goloritzé, Sardinia
Anjuna Beach, North Goa, India
Shoalhaven, Australia

OFF THE GRID WITH

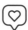 @offthegridwith

 Sweden

Life's too short for the safe path

 2009 Mercedes Sprinter

Exhausted and run down from working tiring fifty-hour weeks while desperately wishing for a change in lifestyle, Maja took control of her future and steered it towards what makes her happiest in life: travel. In 2018, she converted a camper and embarked on a solo adventure, travelling full-time in her 2009 Mercedes Sprinter van through a total of eighteen countries while working as a sports photographer and recording her experiences as 'Off The Grid With'.

Downsizing from a tiny house in Sweden into a smaller, four-wheeled home, Maja sold anything that didn't have a place in her new life. The process of detaching herself from so many useless, material things lifted a weight inside her, reaffirming that a simplistic life was exactly what she needed to nurture her mental wellbeing. And that process has stayed with her on the road; with less room for storage and more time spent away from the city in the heart of nature, Maja finds that all she really needs is fuel (gas) in the tank, food in the cupboards and a beautiful place to relax and enjoy life in the slow lane. If her budget is tight, then she'll stay in one place longer, spreading her funds and using her time to connect with the road-life community both online and on the road. Cooking fresh meals helps to keep costs to a minimum, and Maja's lifestyle while travelling isn't one that requires a lot of money to begin with. Avoiding tourist hotspots and the traditional sightseeing costs, parking in nature and needing few material things to live means she can manage her finances easily, allowing her travels to continue indefinitely. And if funds begin to

run dry, she simply looks for photography work and tops up her savings.

Maja designed every element of her van from scratch without any training. She never set out to build 'the perfect van', but rather something that she felt proud of, using her vision to create a cosy, comfortable camper that would allow her to live the life of her dreams. Criticism for her new venture and negativity about her lack of skills from onlookers dogged her wherever she turned, but Maja is anything but a quitter. She soon proved to all the naysayers just how powerful self-belief

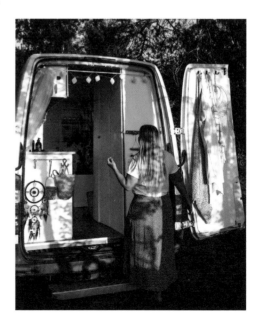

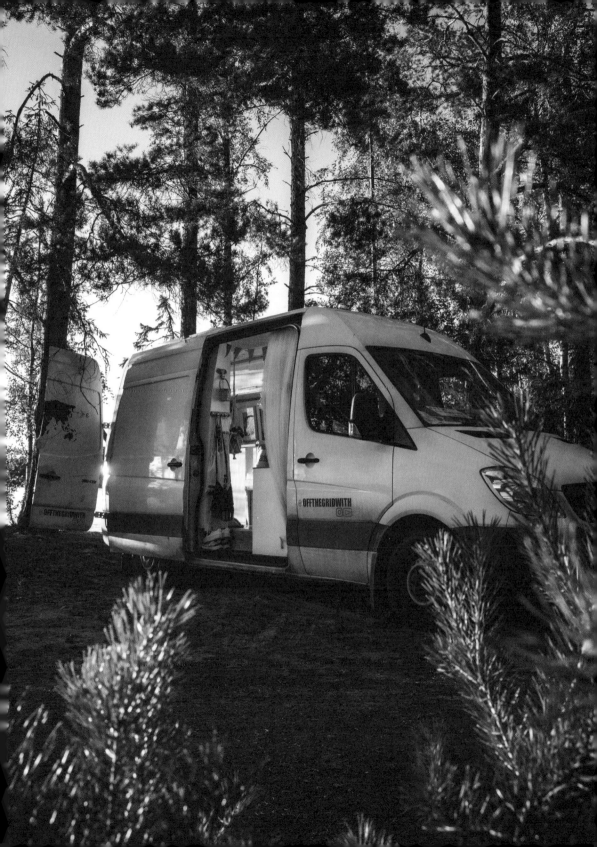

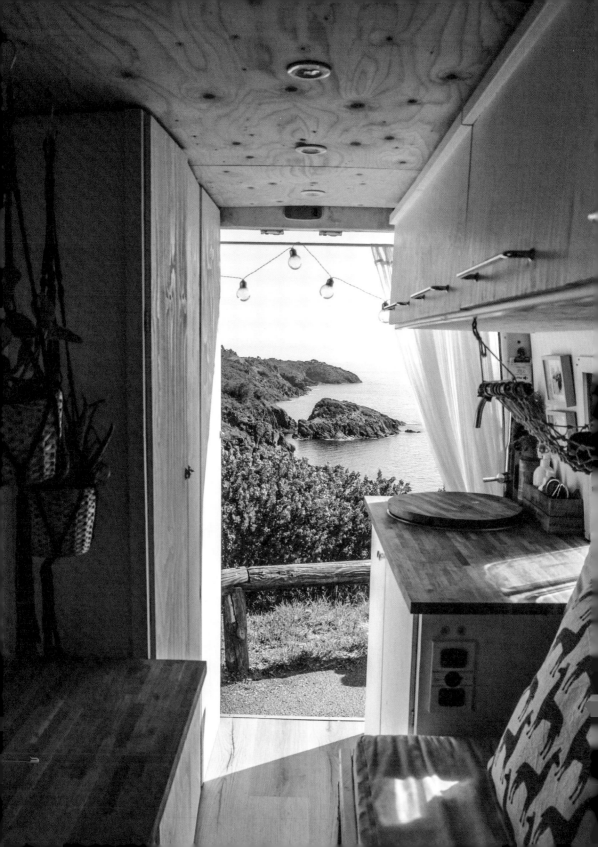

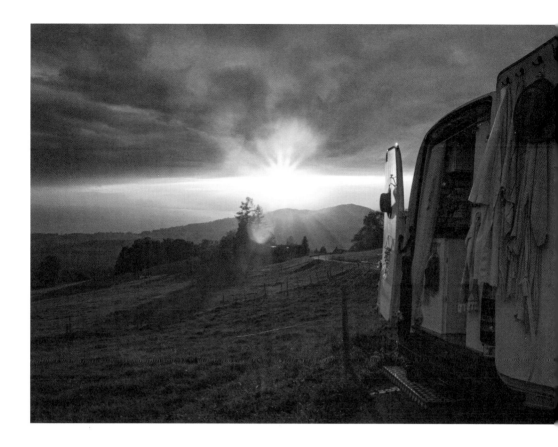

and determination can be and now leaves many longing to follow in her footsteps.

Life on the road as a solo traveller appeals to Maja as she feels comfortable in her own company. Wild camping gives her the freedom to be alone with nature, often using apps such as Park4Night to find relaxing spaces next to lakes or the ocean, places she can call home for as long or as little as she chooses. She is always bumping into fellow road lifers on her travels and regularly meets up with friends she has made in the community, her initial fear of introducing herself to strangers or feeling out of place among couples now a distant memory as she openly invites them to play board games with her and throws herself into all manner of exciting challenges. Apps like Instagram allow her to chat to fellow members

of the community online and arrange meetings with people in advance, plus her vast social media following are always on hand to help with translations on the road should she find herself in trouble.

Safety is paramount as a solo traveller, and Maja has designed her van with a door into the driver's cabin so she can drive away from any unsavoury situations or places that make her feel uncomfortable without having to go outside. She's no stranger to parking up in new locations at night and finds it no different than walking home from the bus stop after a night out with friends.

As Maja rightly says, 'Scary things can happen anywhere no matter how you live, and you can't let fear stop you from living your best life. You only get one, after all.'

OFF THE GRID WITH

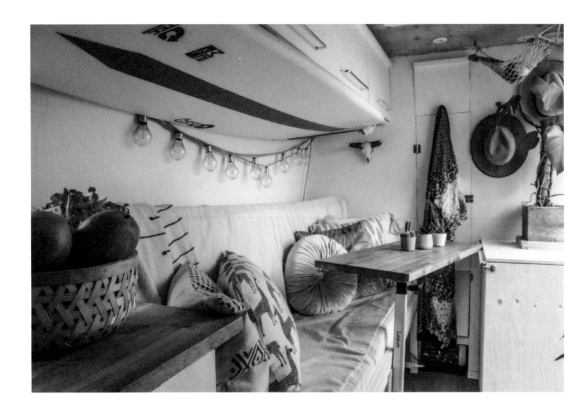

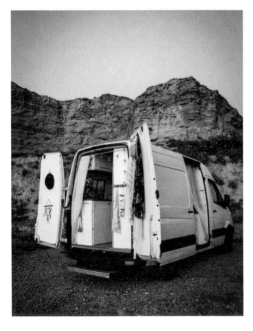

THREE ESSENTIAL ITEMS

→ My bug slayer

→ All the storage, especially for my games that I bring on the road

→ My toilet

MOST MEMORABLE DESTINATION

→ Probably Sardinia or Greece... it's too hard to choose!

→ If you like the sound of sunny Sardinia or the golden beaches in Greece, then check out:
Makena Beach, Maui, Hawaii
Restonica Gorge, Corsica
Brač, Croatia

'Design your van for your
needs and what you want.
Don't compare it to other vans.'

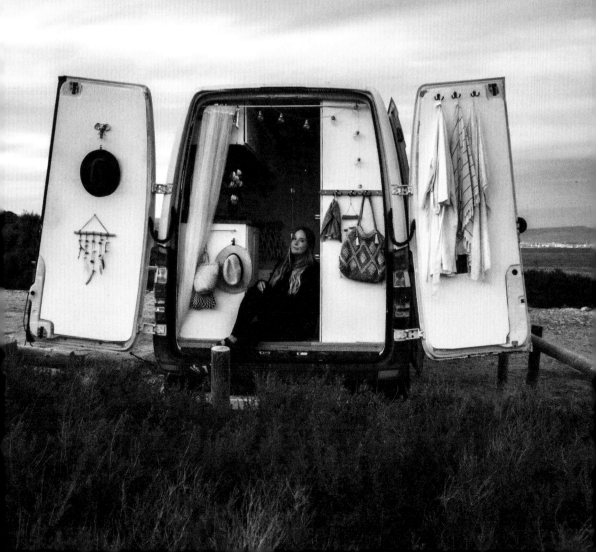

ALEXANDR AND YANA

 @vanliferussia

 Russia

Adventurous family exploring Russia

 2008 VW Crafter

Back in 2017 when the Russian road-life community scene was still in its infancy, Alexandr and Yana bought an old Nissan campervan and set about converting it into a rolling home. Taking a break from their jobs at a popular Russian TV channel, they embarked on an adventure to Georgia, gaining a taste for a simpler way of life and returning with a lust for adventure. Now, along with their eighteen-month-old son, they travel continually in their self-converted VW Crafter, exploring the Russian wilderness and taking hands-on parenting to the next level.

Travelling full time with a young child has its challenges, but Alexandr and Yana are more than up for the task. When they are not working on informative YouTube videos or selling handmade clothing online, they can be found out in nature among the animals and insects, showing their son the real world that he lives in and the different peoples that reside in his vast country.

Spending just 30,000 roubles per month (around £300/$500 at the time of writing), Alexandr and Yana have everything they need to raise their son, eat well and live comfortably while travelling full time. They also kept costs down in the building stage by doing the bulk of the conversion work themselves, using the skills learned from their first conversion while avoiding time consuming and costly problems that otherwise might have caused setbacks. Their setup is simple but effective, with a double bed for the parents and a hanging bed for their son. Storage comes in the form of a large trunk that houses all their clothes, and a gas water heater

provides hot water for showering and washing. Solar panels provide all the electricity they need for a nomadic lifestyle, and a surfboard slung on the outside of the van is ready and waiting for the next adventure to the ocean.

Alexandr and Yana are proof that travelling as a family doesn't have to cost the earth, and since Russia has close to 17 million square kilometres (6.5 million square miles) of land spanning two continents, they certainly don't have to worry about getting a change of scenery. This family loves having the ability to thoroughly immerse themselves in so many different cultures, enjoying the hustle and bustle of Moscow to the hospitable people living in the alpine villages of Dagestan, all for less than what most people set aside for their monthly bills alone.

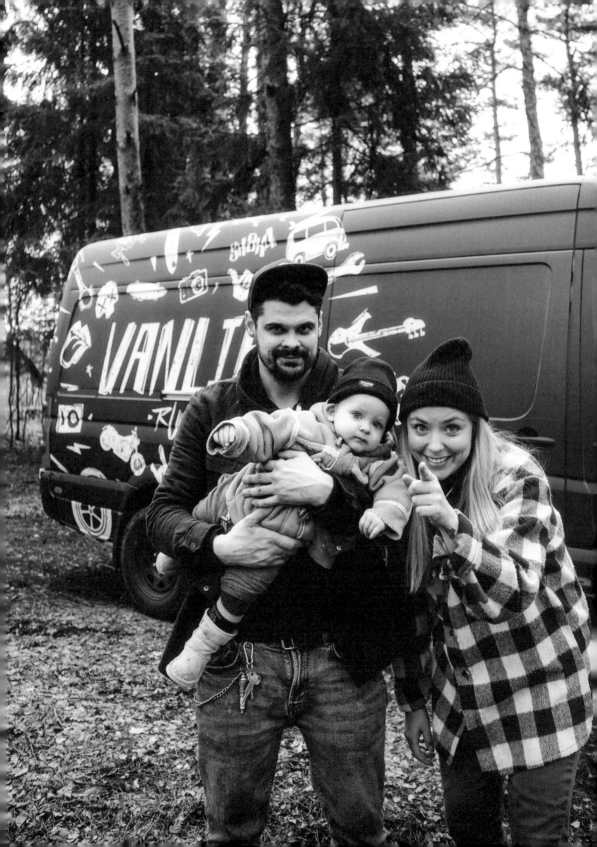

'Spend your money wisely and get a big refrigerator. Our food went off quickly at first, which was very wasteful.'

THREE ESSENTIAL ITEMS

→ Refrigerator

→ Plenty of child's toys

→ Shower and a toilet

MOST MEMORABLE DESTINATION

→ Everywhere is wonderful in its own special way, but the gorgeous Sulak Canyon and breathtaking surrounding mountains of Dagestan won our hearts

→ If you like the sound of the Sulak Canyon, then why not consider planning a trip to:
 Glen Canyon, USA
 Dadès Gorge, Morocco
 Fish River Canyon, Namibia

ALEXANDR AND YANA

MAO HENRY

 @maohenry

 Japan

 2012 Mazda Bongo

The whole world is a campsite

When the Coronavirus pandemic hit the world back in 2020, many people found that their world had come to a standstill. But not Mao. After binge-watching DIY and camper conversion technique videos at home, he bought a second-hand Mazda Bongo and set about converting it into a cheap yet cosy home on wheels, ready to explore the stunning beauty of the Japanese countryside the moment lockdown lifted.

With a small budget of ¥500,000 (around £3,300/$4,400), Mao managed to buy and convert his camper. Utilizing lots of cost-effective materials such as an OSB board to create a 'camping room' as opposed to a traditional motorhome conversion. Mao has always loved camping and sees his van as an extension of his vast array of outdoor equipment. So much so that most of the storage in his camper is dedicated to the gear he used on his adventures before road life, and still continues to use, all of which make living a nomadic lifestyle and travelling on a shoestring budget a breeze.

By building an extendable bed that he can stretch out on and nifty shelves for everything from teapots to a tambourine, Mao has made use of every inch of the compact space inside his van. As he's used to camping without amenities, his van doesn't have a solar electricity setup or a water tank. He charges his laptop and phone from a portable powerpack and collects water on his travels or from campsites. And, with the addition of a large awning, Mao can extend his living space and bring nature into his home, creating a large communal area for friends to gather or for working on more DIY projects.

Mao often travels alone, but he never feels lonely. Living in the moment and travelling from place to place to meet up with other road lifers and camping lovers, he describes his life as one that is rich and content, thankful to be out roaming through his beautiful country. He mostly visits sightseeing spots and campsites – the vast bear and boar populations in the mountains make wild camping dangerous – but he manages to keep costs down by cooking simple, tasty meals and avoiding paying tolls by taking the slow roads while travelling on highways.

And while road life is still in its infancy in Japan, more and more people are adapting their cars and converting vans for mobile camping. Mao enjoys watching the progression of the movement in Japan and hopes that by posting his adventures on Instagram and YouTube, he can connect with others and show them that travelling on a budget is not just possible, but exciting and fulfilling, too.

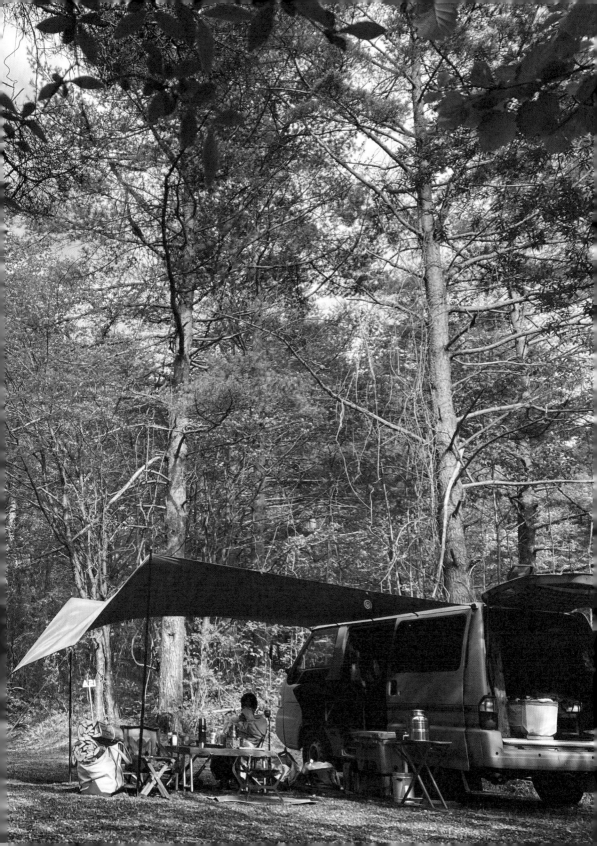

'Cook simple meals.
You don't have to eat
extravagantly to be happy.'

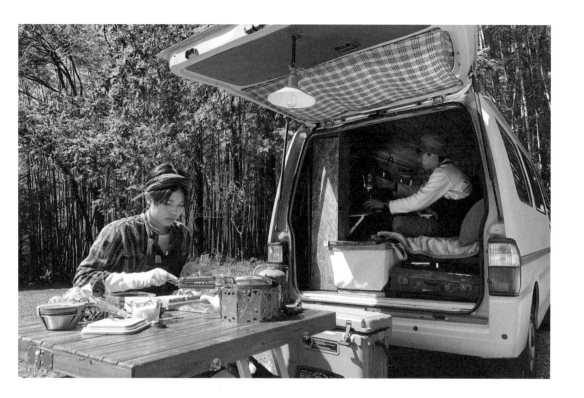

THREE ESSENTIAL ITEMS

→ Powerpack

→ Camping equipment for cooking

→ Tools for DIY on the road

MOST MEMORABLE DESTINATION

→ Fumotoppara Campground – it's a beautiful place where you can spend time looking at Mt. Fuji right in front of you! If I make foreign friends, this is the first place I take them

→ If you like the sound of Fumotoppara Campground, then why not consider travelling to:
 Curry Village, Yosemite National Park, USA
 Brecon Beacons, Wales
 Dolomites, Italy

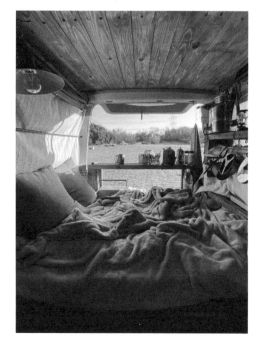

MAO HENRY

CURLY HAIR CAMPING

Take your life in unseen directions

 @curlyhaircamping

 Czech Republic

 2015 Fiat Ducato

When Margaret travelled from America to tent camp across New Zealand back in 2016, she had no idea that she was about to fall in love with road life and the man who would become not just her business partner, but her life partner, too. Since then, she and her boyfriend Ladi have lived and travelled in over nine different vehicles through thirty countries, seeking out inspiration for the ultimate DIY campervan and documenting their journey as @curlyhaircamping.

Margaret and Ladi are campervan experts. When they're not living in vans, they're building them. And when they're not building them, they pass on their knowledge to the road-life community through their YouTube channel, *Ladi and Margaret*, and social media channels. They are currently on a mission to build a self-converted campervan with two showers, a built-in 3D printer and the biggest panoramic roof windows ever installed in a panel van. It's safe to say that they live for designing and creating; it's how they came to own and manage a business making and selling e-bikes to fund further conversions and adventures, and they've certainly spent enough time living small to know which comforts they can live without, and which ones are essential for prolonged life on the road.

The one thing that Margaret and Ladi love more than converting vans (aside from their furry companion Millie) is travelling to incredible places in them. They come across most of their park ups by chance and wild camp wherever possible, relishing the calming simplicity that compliments their lifestyle and an immediate access to nature.

Living an outdoorsy life works as a tonic to calm the couple's anxieties and stresses, positively affecting their mental and physical health. Plus, with forest trails and bike paths right outside their sliding door, they have every excuse to spend as much time outside as humanly possible.

Still, as an American citizen, Margaret had trouble gaining visas for international travel. With entry and exit days for the countries they passed through in Europe, proper route planning was essential. She's since been able to secure a three-year temporary resident visa for the Czech Republic, Ladi's country of birth, thanks to their long-term partnership.

When it comes to building on a shoestring budget, Margaret and Ladi rely on the sales of their e-bikes and their YouTube income to fund their conversions. They've been at both ends of the scale, converting vans that have cost £1,500 to nearly £19,000 ($2,000 to $25,000); even the higher sum is still a fraction of most professionally built adventure vehicles thanks to their passion for DIY.

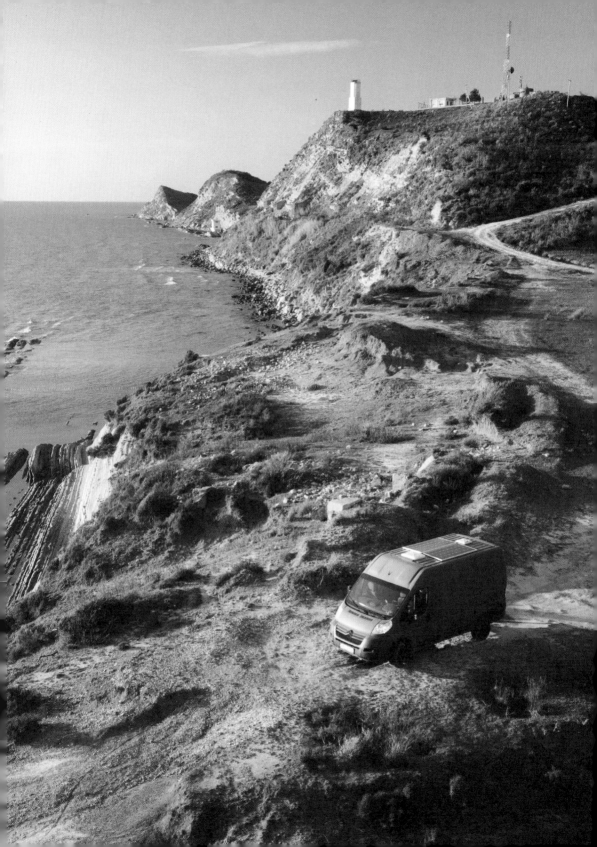

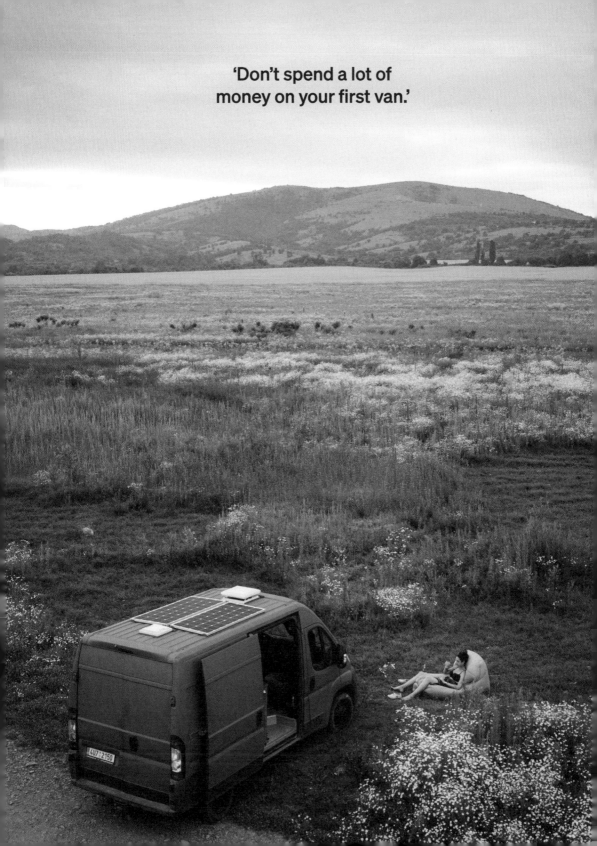

'Don't spend a lot of
money on your first van.'

THREE ESSENTIAL ITEMS

→ Running water – I don't think that I could live without it anymore

→ Solid phone mount for driving

→ Solar panels – at least 300W

MOST MEMORABLE DESTINATION

→ Cappadocia, Turkey. It's the best national park we've ever been to

→ Been to Cappadocia and looking for something new? Why not try:
Bagan, Myanmar
Grand Canyon, Nevada, USA
Uyuni Salt Flats, Bolivia

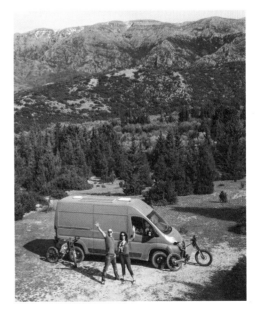

CHARLY CHEER

The world is my playground

 @charlycheer

 USA

 'Tangerine' – 1978 Dodge Robinhood Archer

Thirty-four-year-old Charly has always dreamed of living the road life. After living abroad in South Korea, Mexico and Vietnam for a large portion of her adult life, she returned to the USA and lived out of her car for just short of a year before buying her Vintage 1978 Dodge Robinhood Archer back in February 2021. With her plan of becoming a flight attendant and living in hotels for portions of the week, the idea of renting a house that would only be sitting empty felt irresponsible and would be a strain on her bank balance, to say the least.

Combining a lust for adventure with a notion of cheaper living, Charly flew to Oregon and made the ten-hour drive back with her classic RV, the first of many road-life adventures. And while most people might have been daunted by moving into a small space such as her Archer, moving from a Mini Cooper to a 6.5 metre (21 foot) RV with four beds, a kitchen and a bathroom felt like living in a mansion.

Driving an old vehicle requires you to have some knowledge of how to deal with mechanical faults on the road, and Charly has created a checklist of things to look at every time she sets off. From inspecting coolant to keeping on top of transmission fluid, Charly has come to know her RV 'Tangerine' like the back of her hand. And when things get really rough, her roadside assistance service are only a speed dial away.

Living cheaply and travelling on a budget allow Charly to get out and explore as soon as she touches back down onto US soil. She uses a reusable 23-litres (5-gallon) water jug that can be filled up at Walmart for around 75 pence ($1),

or free water points at RV parking spots. By shopping at discount stores and cooking meals at home, she's able to live within her means without having to worry about keeping money aside for a house rental, and she can park her mobile mansion at the airport when it's time to head to work.

For people like Charly, road life isn't just a means of getting out in search of pastures new; her RV is her full-time home whether she's travelling or not, providing a more affordable way of living with all the comforts of home at her fingertips. Plus, with the option of ever-changing scenery and a quirky home on the table, it's unlikely that Charly will ever go back to living in a house again. Who can blame her?

'Go slow. You don't need everything all at once.'

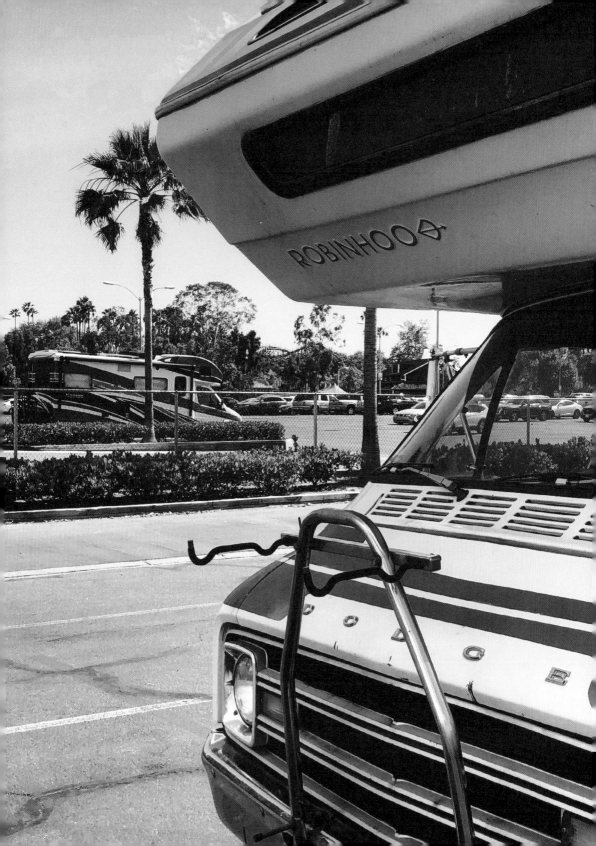

THREE ESSENTIAL ITEMS

→ Portable power station with solar power to charge all my gadgets

→ Mobile (cell) phone hotspot to share with my other electronic devices

→ Cleaning supplies because RVs get dusty super fast

MOST MEMORABLE DESTINATION

→ Definitely the drive from Oregon to California. It was so beautiful and scenic, the first and best road trip so far

→ If you like the sound of Charly's epic drive from Oregon to California, then why not consider planning your own road trip along:
 The Alcan Highway, Canada to Alaska
 Causeway Coast, Northern Ireland
 Amalfi Coast, Italy

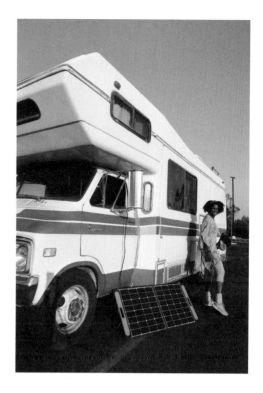

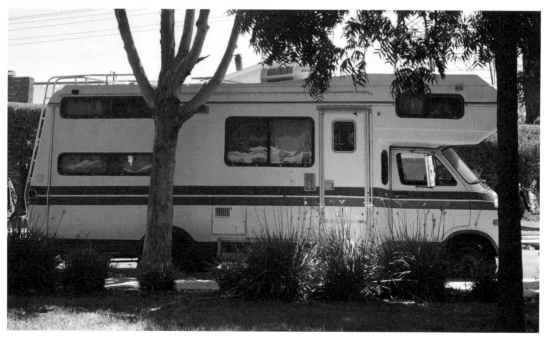

HOW TO BUDGET FOR FULL-TIME ROAD LIFE

I made a list of how much I spent while travelling through Europe in 2019. These costs will fluctuate from person to person and from year to year, but my total spend for one month came to just £445 (around $600). Here's a breakdown of my budget:

40%

FUEL AND TOLLS

Like food, fuel is necessary for living on the road. If you want to make your fuel last longer, then keep things simple and just stay somewhere beautiful for a few more days.

34%

FOOD

Everyone has to eat, but food doesn't have to be expensive on the road. It's easy to keep costs down by buying fresh ingredients and cooking in your van.

12%

BILLS AND ENTERTAINMENT

This covers bills for Spotify, Audible and my phone bill. Top tip: sign up for Spotify Family with other members of your family and split the cost.

8%

MAINTENANCE AND ESSENTIALS

This mainly accounts for vehicle tax, but doesn't include an annual insurance payment, which will differ between drivers.

3%

WASHING

This depends on how frivolous you are with washing both your clothes and your body. Find a hot spring and it's free!

2%

TOURISM

Usually every couple of months for entry to tourist attractions.

1%

EVERYDAY SUPPLIES

The average of monthly budget spread over the year and includes anything from camera film and batteries to tea lights, matches and poster putty.

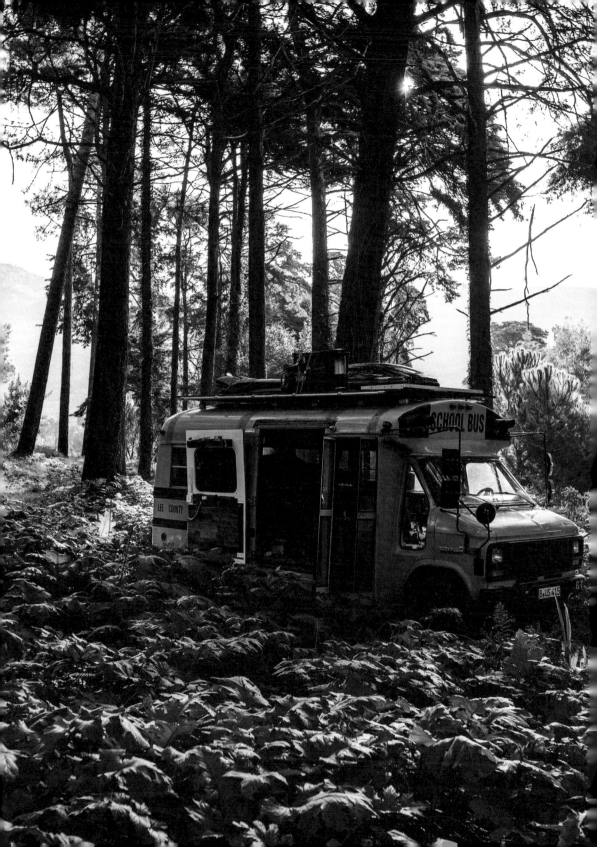

5

CLEANER LIVING

Travel isn't the only motivation that drives people to live life on the road. For many, it's an urge for a cleaner and more self-sufficient way of life, a chance to leave old habits behind in favour of renewable energy sources and safer environmental practices, using fewer consumables and reducing the amount of waste they dispose of along the way.

Water collection systems, solar panels, composting toilets; there are so many products available that make living a greener life on the go accessible to all, and the adventures that our next set of road lifers have all embarked on prove that having a tiny environmental footprint doesn't mean that you have to live a small, secluded life.

But cleaner living in the road-life community isn't just about thinking about how to improve your own life; it's about improving the world for our generation and the generations to come. Whether championing the values of responsible road life through online talks and meetups or ridding the world of rubbish one park up spot at a time, there is always something you can do to make the world a better place and to keep beauty spots open for the road lifers of the future.

The time to act is now, so here's some inspiration on how you can live free and do your bit to save the planet!

ROUTE DEL SOL

 @routedelsol

 Australia

Doing what's right, not just what's easy

 2010 Navistar International E-Star

After growing up with a love of camping in RVs and outdoor adventures, Joel set a plan in motion to build a fully solar-powered vehicle for the ultimate road trip. Utilizing skills learned from a double major in Ecotourism and Climate Change Adaption alongside a passion for environmentally friendly technology, Joel transformed an electric Navistar truck into the world's most capable all-electric camper that runs solely on the power of the sun, before setting off on a journey from the Arctic Circle to the very tip of Argentina back in 2018.

Joel's solar-powered vehicle conversion cost around £37,500 (around $50,000) and boasts a charging module that folds out to reveal twenty-four solar panels. He harnesses the sun's power to run everything from the cooker to the camper's engine, providing him with more than enough energy to live comfortably. He can drive around 200 miles (around 300 km) off a single charge, each charge taking about two to four days depending on the weather. If there's no sun, Joel waits until the elements are on his side before setting off on the road, not living by a schedule and taking his adventure at his own pace.

Joel's love of the outdoors instilled a deep longing to live as low an impact lifestyle as possible. He primarily cooks plant-based meals on the road except when catching his own food and follows the principle of 'reduce, reuse, recycle' when it comes to plastic goods. His motivation lies within the sustainability of the human race and his efforts in convincing people across the globe that protecting the world starts with re-educating ourselves on how we live moving forward.

When it comes to living on the road and travelling to beautiful locations on his epic expedition down the planet, Joel has many tricks up his sleeve for restocking supplies. He lives off a small budget, usually around £300 ($400) a month, with his main costs being insurance and food. Engaging in conversations about climate change with like-minded people often leads to a driveway to park on for the night, with water being exchanged for a tour of his incredible creation and an in-depth lesson on solar energy.

Even when Joel's solar module was damaged due to high winds in 2020, it didn't stop him from fixing his rig on the go and continuing his mission. With major partners now on board and news stations clamouring to chat to the adventurous man with the solar-powered van, Joel's hopes of a safer and more sustainable future for all could become a reality sooner than even he dares to dream.

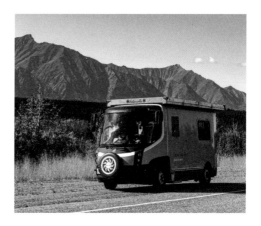

THREE ESSENTIAL ITEMS

→ Surfboard

→ Cameras

→ Laptop

MOST MEMORABLE DESTINATION

→ Kluane Lake, Yukon Territory, Canada, under the Northern lights

→ If you like the tranquil sights of Kluane Lake, then consider planning a road trip to:
 Lake Bled, Slovenia
 Todos los Santos Lake, Chile
 Lake Annecy, France

LET'S PLAY RIDE AND SEEK

Happiness is in the pursuit

 @letsplayrideandseek

 USA

 2004 Mercedes Sprinter High Top

Swapping fifty-five-hour working weeks for the open road and a cleaner, more sustainable way of life was all it took for married couple Nat and Abi to discover what truly made them happy. They sold everything, paid off their debts, and bought a 2004 Mercedes Sprinter, embarking on a fulfilling journey with their two dogs that has seen them travel through three countries, thirty-two National Parks and forty states. Excited by clean living, vegan cooking and all things outdoors, Nat and Abi are the experts when it comes to living responsibly on the road.

Recording their adventures as 'Let's Play Ride and Seek', Nat and Abi always count the experiences they share as a couple over work. Still, their efforts in teaching their audience about everything from following their travel dreams to championing conversations about diversity in road life have captured the attention of a global audience. As the founders of @vanlifepride, they have created a safe and ever-growing community for queer nomads on the road and a platform for others to share their experiences and grow as confident travellers.

Nat and Abi have converted the same van twice throughout their travels, striving for that perfect moving home that complements their off-road needs. They've met lifelong friends along the way and learnt a lot about what it means to live small. They earn a little but make it go a long way, easily covering costs such as vet bills, food, insurance, phone bills and more. By wild camping responsibly in nature, they live a slow, tranquil life that is both kind to their minds and the planet.

Nat and Abi eat a plant-based diet. It keeps them physically and mentally strong and allows them to buy local while reducing the amount of single-use plastic in their lives. Their leisure batteries are continuously topped back up by the sun, they compost and reuse wherever possible and they strive to keep campsites cleaner than they found them for others to enjoy. Plus, they manage to find time to work with the National Forest Foundation to advocate their way of life to others alongside all their other important efforts for the road-life community.

As a chef by trade, Nat knows a lot about the benefits of creating sumptuous dishes with vegetables. With plenty of fresh leafy greens, legumes, beans, nuts and herbs onboard and a dash of creativity, a nutritious meal is never far away, and makes using a toilet in a tiny space a lot more bearable, too!

Nat and Abi are a treasure trove of knowledge. Not only do they continuously give back to the community, but they help to nurture its members and assist them in realizing their true potential. I think it's fair to say that the future of road life is safe in their hands.

'All that really matters is the ability to love one another while experiencing the earth's beauty.'

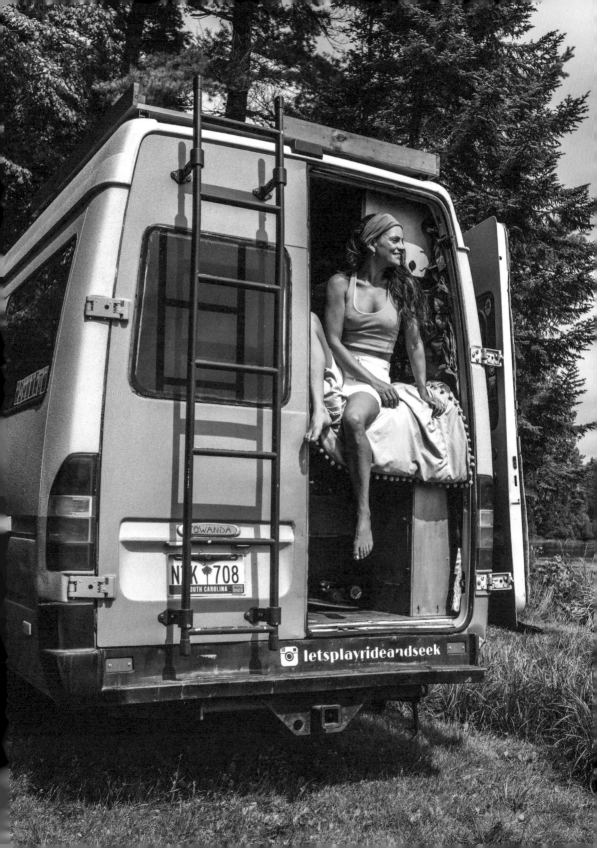

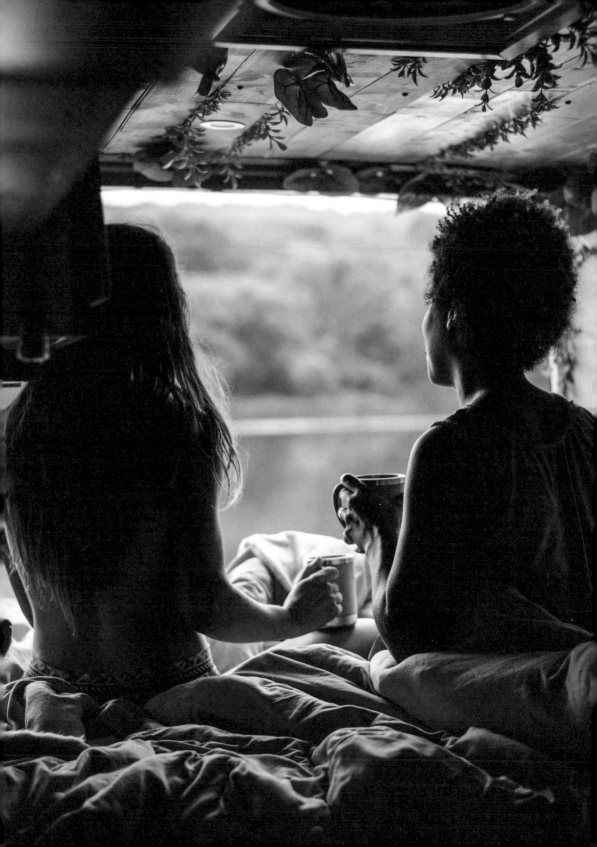

THREE ESSENTIAL ITEMS

→ Can we say our dogs?

→ Water filter system – we fill up with water at so many different sources. Knowing our water is clean and safe to drink gives us peace of mind. Water is life!

→ Chef knives – cooking is such a huge part of our daily life and Nat has to have her tools

MOST MEMORABLE DESTINATION

→ Todos Santos, Baja California Sur – the first time we slowed way down and actually felt the heartbeat of a place. We met some lifetime friends there and ended up doing pop-up restaurants on the beach out of the van. We sold out every event, and the energy was like no other. So much community and valued memories. Waking up to whales breaching out your window every morning and evening – can't beat it

→ If you like the thought of sandy beaches and stunning ocean views, then consider planning a road trip to:

 Shark Beach, New South Wales
 San Juan Islands, USA
 Saltvik, Iceland

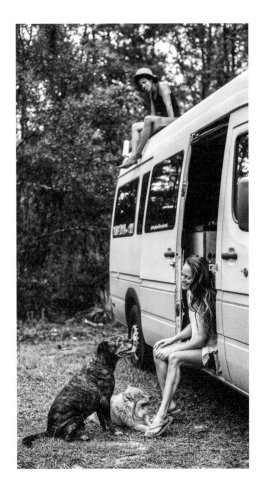

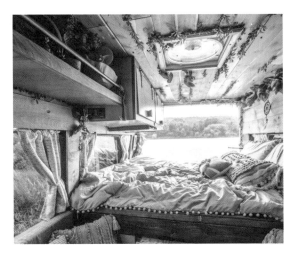

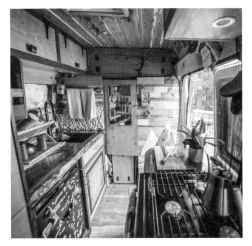

WE TRAVEL BY BUS

Self-sufficient school bus promoting responsible road life

 @wetravelbybus

 Germany

 Converted School Bus
1993 GMC Vandura

For some people, road life isn't just a choice; it's a calling. When Kai found a school bus for sale while on his way to buy coffee, he never intended it to become his full-time home. Still, with a yearning to live an alternative lifestyle already growing in his mind, Kai purchased his 1993 GMC Vandura and headed out on a climbing trip, instantly loving the freedom and minimalistic way of life that road life brings. He sold his apartment one year later, moved into his bus full time, and now lives an eco-conscious, self-sustainable lifestyle producing his own drinking water through filtering and generating electricity through solar panels while travelling the world. For his next trip, he plans to leave the EU for the first time to explore the Asian Continent, taking in Turkey, Georgia and wherever else the road will take him.

Kai's skoolie is the ultimate off-grid paradise, complete with a composting toilet (no need for a trip into the woods), ample power to keep batteries charged for his work as a Filmmaker/Photographer, and a cosy woodburning stove, a feature that taught Kai the lesson of sticking to your dreams and daring to try what others won't.

Prior to embarking on his road-life adventure, Kai had no knowledge of the interior workings of American cars, let alone how to maintain an old school bus. Five years later, however, he and his skoolie are in perfect sync with one another, and he knows his way around the engine just like you might a fuse box at home. It makes heading out on long journeys into the middle of nowhere seem less daunting knowing that you can get

yourself out of most sticky situations, and it also saves on expensive bills after visiting a garage or a mechanics.

For Kai, clean living is about people doing the best they can in their own individual situations, and saving the planet starts with rethinking how we live our day-to-day lives. His bus is equipped with a system that allows him to filter and store 100 litres (around 25 US gallons) of water collected everywhere from lakes to fuel (gas) stations, which usually lasts him about a week while on the road, including having the odd outdoor shower. Kai isn't a stranger to jumping into a refreshing river or a hot spring to bathe, however, which is a treat that is as close to road-life Valhalla as a nomad can possibly get and one that has incredible positive effects on a person's mental health.

Kai is a huge advocate of living a responsible road life. Living small and relying on less plastic, fewer consumables and using fewer resources is a huge step in the right direction whether you live out of a truck camper or a tiny trailer. His adventure bus has given lots of people food for thought when it comes to leading a more self-sustainable lifestyle while proving that campervans are 100 per cent more inviting with a cosy wood burning stove on board.

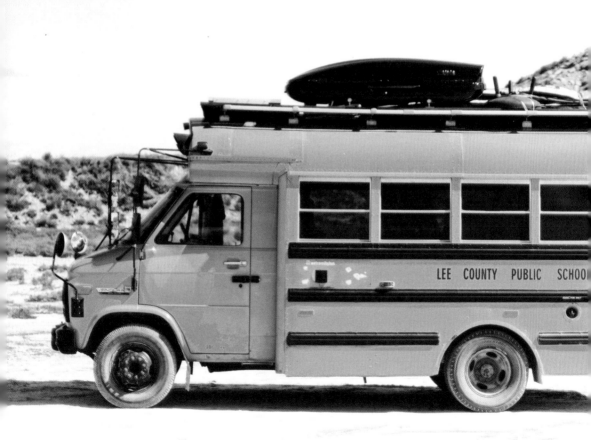

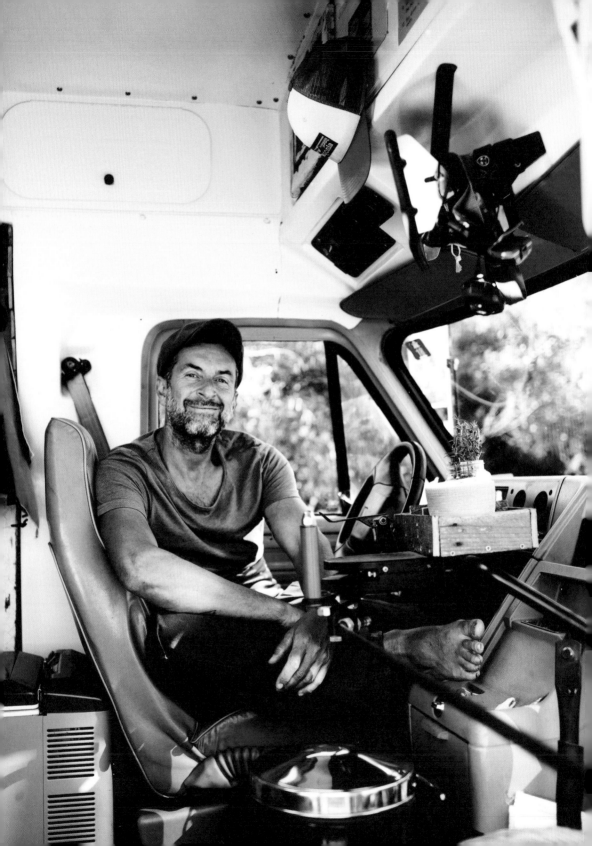

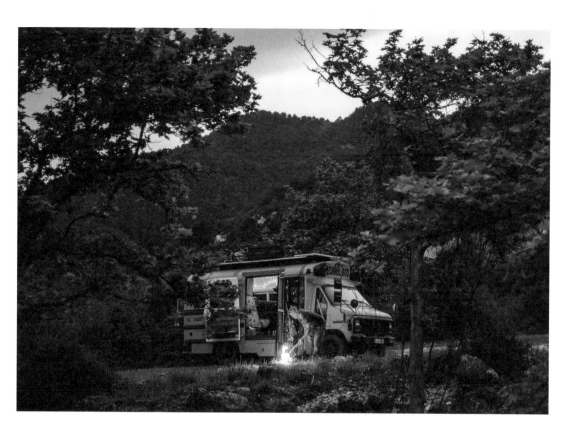

THREE ESSENTIAL ITEMS

→ My cats

→ My woodstove

→ My dirt bike

MOST MEMORABLE DESTINATION

→ Iceland. That was a great experience and
 photography heaven

→ If you like the sound of Kai's trip to Iceland,
 then perhaps plan a road trip to:
 Mykines, Faroe Islands
 Geirangerfjord, Norway
 Katmai National Park, Alaska

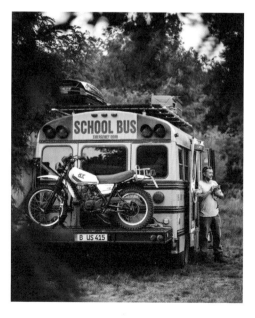

THE TRASH TRAVELER

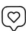 @thetrashtraveler

 Portugal

Enjoy nature, but protect it

 1982 Carthago

Few people have done as much to keep the road-life scene as clean as molecular biologist Andreas, aka The Trash Traveler. Over a 160-day period at the beginning of 2021 he collected over a tonne of trash, mostly plastic, while travelling up the Portuguese coast in his self-converted camper. A few months later, he topped this record by organizing a trash collecting hike along the coast, leading more than five hundred participants on a 1,132 km (just over 700 miles) expedition from the Rio Minho in the north to Vila Real de Santo António on the southern border with Spain, collecting a further 1.6 tonnes of trash and plastic that had washed up from the ocean.

And the best part is that Andreas travelled through adverse weather conditions and demanding terrain with just one refillable water bottle, proving that there is no need whatsoever for single use plastic in today's world.

Throughout all of Andreas's challenges, his constant companion has been his rolling home. Whether driven from location to location by Andreas or following his progress with the help of a friend while he travels on foot, his trusty 1982 Carthago is always there to provide a comfortable place to rest his head. In true keeping with his minimalistic approach to life, Andreas' camper has no electrics, no fridge and no shower. He values the little things in life and lives by the philosophy that if you don't have much, then you can't lose much.

Andreas's tiny living adventure began after he finished his degree while working as a medical consultant. His van provided free accommodation close to the office, leaving more time for surfing and relaxing in a sauna instead of sitting in traffic jams during the morning commute. His role as The Trash Traveler was born out of him having more time to see the world around him, a chance to take note of how people are abusing it. If it wasn't for road life, he wouldn't have quit his job and dedicated his life to making the planet a safer, cleaner and more environmentally friendly place.

This reliable 1982 Carthago has recently played a huge part in another important expedition – the Butt Hike. At the time of writing, Andreas and a team of six hundred volunteers with seventy NGOs (non-government organizations) have just completed a mission to collect one million cigarette butts on their travels throughout Portugal, preventing harmful plastic and toxins from making their way into the ocean. With the road-life community and Portuguese journalists following and supporting Andreas's spectacular challenges, we're sure to be seeing a lot more of his little blue van trundling up and down Europe as he and it do their bit to protect the planet.

'If you get to a place, clean even the trash of others. Doing this puts road lifers in a good light.'

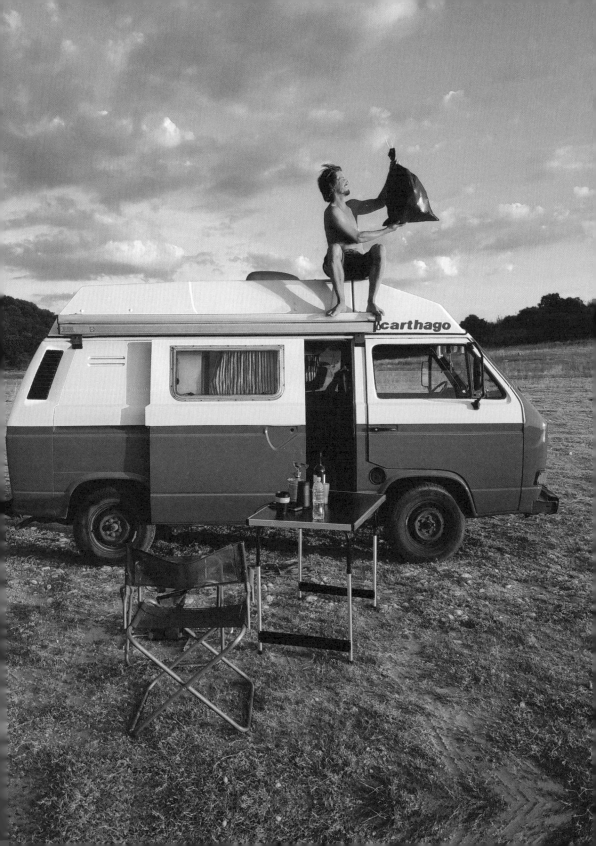

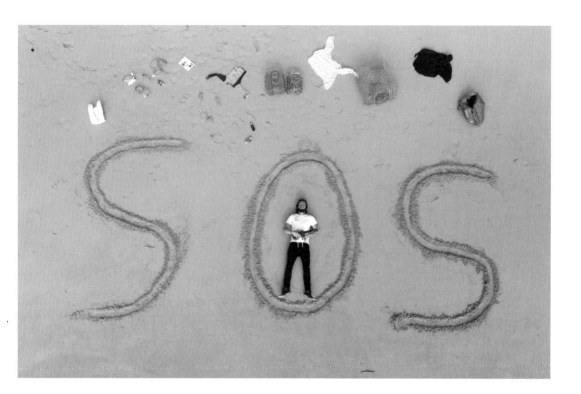

THREE ESSENTIAL ITEMS

→ My ukulele – for writing songs on the go

→ Ecological soap bar – for cold showers outside

→ Trash bag – for trash travelling duties

MOST MEMORABLE DESTINATION

→ Portugal is beautiful and changes every few metres. That's the beauty of travelling

→ If you like the sound of the Portuguese coast or perhaps the thought of following the winding Douro River, then why not consider taking a trip to:
 Karaburun Peninsula, Albania
 Gibb River Road, Australia
 Lion-sur-Mer, France

HELEN LOUISE

Making small changes to make a positive difference

 @helenlouisehikes

 UK

 1997 VW T4

Freelance copywriter, designer and social media manager Helen lives and breathes sustainable living. Partnering with companies that are focused on the environment and speaking out about cleaner living practices to her growing social media following, Helen is doing her bit to make the world a better place from her travelling VW T4 tiny home. She's passionate about nature and the mental health benefits that come from a free and simple life, using her time to pick up litter during hikes or cleaning recreational areas to prevent animals from ingesting the rubbish we humans throw away all too easily on a daily basis.

Helen knows that sustainability isn't about being perfect; it's impossible for many of us to live a 100 per cent eco-conscious lifestyle in our modern world. But, by making small, conscious changes such as carrying a reusable coffee cup, using a 150W solar panel for renewable energy and avoiding fast-fashion by looking after her clothes and shopping in the charity shops she passes on the road to give old garments a new lease of life, Helen is doing her bit to keep her carbon footprint as low as possible while travelling.

As a solo female traveller, picking the perfect park up spot is incredibly important for Helen. Like so many other road lifers, she uses Park4Night to gain information on potential park up spots here in the UK, but ultimately she uses her gut when parking up for the night. If she doesn't feel safe, she moves on and finds an alternative location or books into a campsite for the night, giving her a chance to wash clothes and top up with water for the days ahead.

Travelling solo might sound lonely to some, but Helen's commitment to cleaner living keeps her among like-minded people looking to give back to the planet and learn more about how our choices affect the environment. She recently took part in the Marine Conservation Society's Great British Beach Clean as part of a fifteen-strong team of volunteers, returning to her cosy VW for a cup of tea made on her two-burner hob in the evening after a long and productive day's work. When not litter picking or adventuring, Helen uses her mobile hotspot to write articles and converse with companies from the comfort of her rock-n-roll sofa bed.

With plans to complete the famous North Coast 500 route in Scotland as well as travels into Europe, Helen is playing her road-life adventures by ear and going with the flow. Her continued efforts in teaching others how to both enjoy and protect the great outdoors continuously inspire others across the globe, and it just goes to show how a small moment of your time can go a long way to making the world a better place.

'Respect the places you visit and keep the message of "leave no trace" in mind whenever staying somewhere new.'

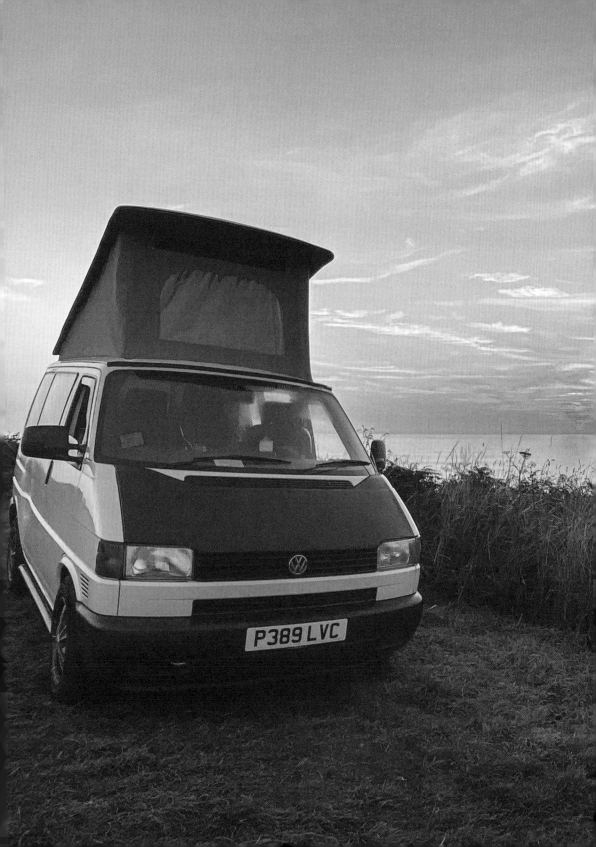

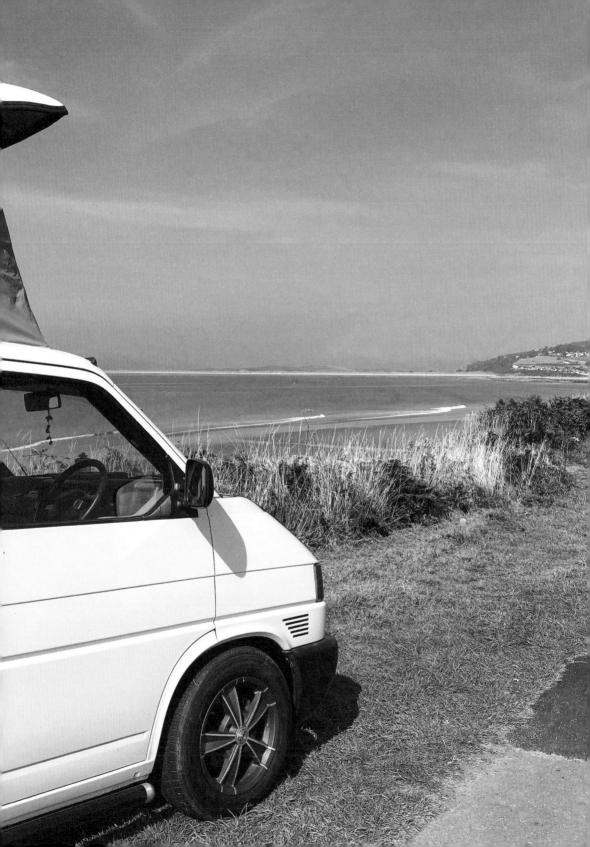

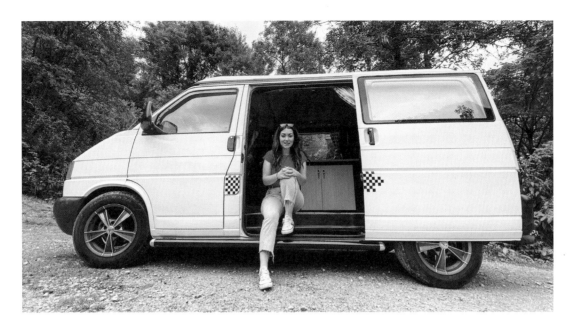

THREE ESSENTIAL ITEMS

→ The solar panel – this means I can stay 'off-grid' for as long as I want

→ My SaltRock Skimboard table – my adventure stickers and ones from the previous owners tell a story of all the places we've explored. It's my dining table, coffee table, TV stand and desk, all rolled into one

→ Unlimited mobile data – I work from my van, which keeps the wheels turning

MOST MEMORABLE DESTINATION

→ The Pembrokeshire Coast – the rugged cliffs that plunge into the choppy waves below are simply stunning

→ If you're enamoured by the Pembrokeshire Coast, then why not consider adding these places to your bucket list:
 Bunda Cliffs, Australia
 Cliffs of Moher, Ireland
 Cape Enniberg, Faroe Islands

SOLAR POWER CHEAT SHEET

1. LIFEPO4 BATTERIES

If you're looking for the perfect off-grid setup, then it's worth investing in Lithium Iron Phosphate (or LiFePo4) batteries. These leisure batteries hold charge for longer, have a deeper discharge rate, and work in extreme temperatures, making them perfect for the trips all year round.

2. SOLAR PANELS

How much solar you need for your individual setup will depend on how much work you need to do. I'd recommend getting at least 200 watts as a bare minimum to keep batteries topped up for charging laptops and running other 12V appliances.

3. SOLAR CHARGE REGULATOR AND DISPLAY

If you're using solar panels, then you'll need a solar charge regulator. This connects your batteries to your solar panels and helps to regulate the flow of electricity.

4. SINE WAVE INVERTER

With all that power stored safely away in your batteries, you need to make sure that you're using a quality inverter to distribute it to your gadgets. A pure sine wave inverter has a cleaner signal and is much kinder to the batteries in your expensive equipment such as laptops and cameras. Around 1000 watts should cover most of your appliances for everyday living.

5. SPLIT CHARGE RELAY

And if all else fails and there is no sun, it's a great idea to have a split charge relay to charge up your batteries while driving. These can be especially useful during the winter months or in periods of bad weather.

SOLAR POWER CHEAT SHEET

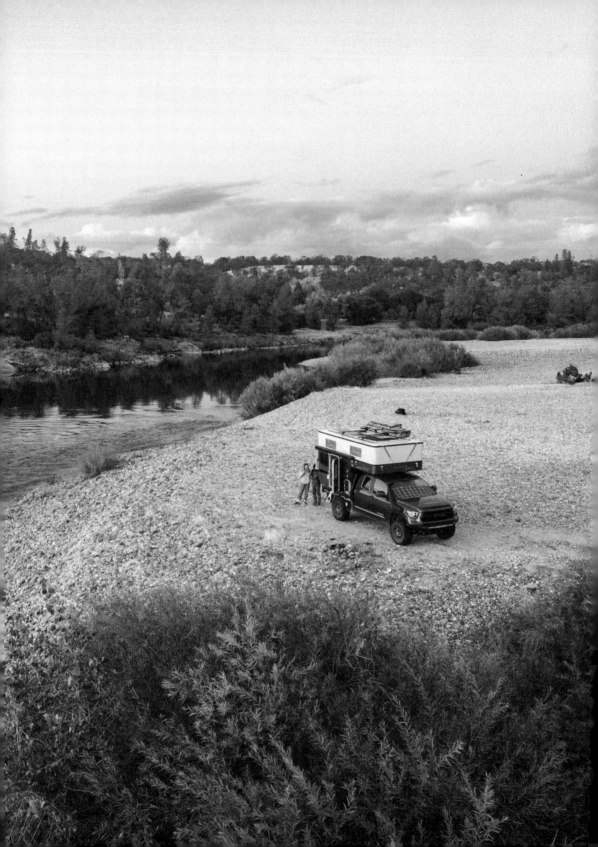

6

OFF-GRID EXPLORERS

You've probably heard the expression 'the world is a book, and those who do not travel only read one page'. Well, the following road lifers haven't just read the book; they've rewritten it, adding their own pages on off-grid exploration along the way and championing the idea of taking the road less travelled.

So much of our world remains a mystery to us, and often the best sights and experiences can't be found in the depths of a travel guide. Whether exploring on foot or driving an off-road vehicle to the very ends of the earth, road life gives us the chance to find secret coves and hidden wonders, delving into unknown territories and wild camping in some of the most secluded spots we find along the way.

For many, it's this kind of off-grid exploration that drives us. It's that thrill of getting off the beaten path, ditching the sat nav before venturing into the wilderness with only our own intuition to get by on. For others, it's simply a chance to prove to themselves and others that they have what it takes to live a different way of life, defying all expectations on conventional living styles and thriving with only the bare necessities to hand.

So, remember; the next time you're planning on booking that city break, consider hiring a 4×4 motorhome and driving away from the crowds instead. I guarantee that you'll have one heck of a holiday that you'll never, ever forget.

TAREK

Creating a life without limits

 @tarek_rollt

 Germany

 2011 Fiat Ducato

As someone who has suffered from muscular dystrophy since birth, Tarek's transition into road life wasn't without its difficulties. With his inability to regenerate muscle after exercise or exertion, the trials and tribulations of taking a camper on an off-grid expedition to Scandinavia looked sure to damage his physical health and wellbeing. Yet despite his friends and family worrying for his safety, Tarek went on to travel not only through Scandinavia but through a total of thirty countries over three years. Instead of his illness putting the brakes on his life, it has encouraged him to get out there and make the most of everything the world has to offer. Not only that, but he has since developed a trike for others heading out on off-grid adventures, giving people without the ability to walk the chance to see the world and enjoy nature.

At just twenty-eight years old, Tarek swapped a loft conversion in the city for a custom-built campervan and an off-grid adventure, taking his self-started media business on the road and managing freelance workers remotely. After discovering he no longer needed a physical office space to trade with his clients, he sold the 14-square-metre (150-square-foot) loft space where he lived and managed a team of three staff along with most of his possessions, before buying a VW T5 and preparing for life in his new 0.5-square-metre (5-square-foot) home.

Eventually, the need for more cooking space and a desire to have a more accessible toilet area instead of using public restrooms prompted Tarek to purchase his more spacious 2011 Fiat Ducato. With his background in media design, he constructed a detailed plan to convert the van himself, alongside his friends, which was implemented to include a full-sized electric retracting bed that lowers from the ceiling and an extendable living space for a relaxing outdoor lounge area.

Tarek has never had difficulty living small, especially inside such a malleable space. Not only does he cherish the ability to live without pressure at his own pace, but he also enjoys discovering new places and meeting interesting people. With the biggest garden in the world on his doorstep and the freedom to live in the mountains or by the sea at a moment's notice, Tarek has never felt more alive.

In recent years, Tarek has decided to include a wheelchair in his travel setup, making tasks such as fetching water and doing the laundry much more manageable and opening more possibilities for reaching new places to explore.

With his sights set firmly on converting an American school bus (skoolie), Tarek is looking forward to an even slower pace of life. Road life has taught him the valuable lesson that freedom means everything, and that even with a disability, his life has no limits.

'Don't dream about road life, start it with what you have right now.'

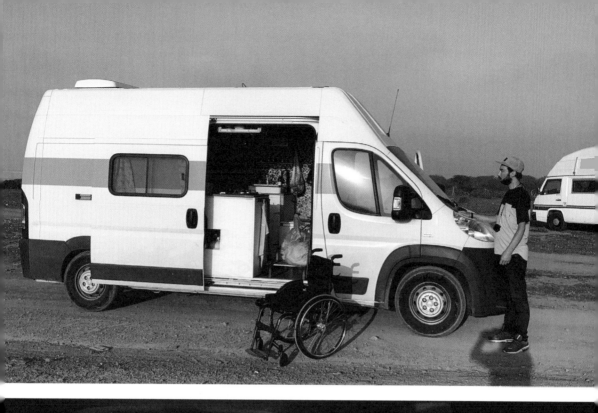

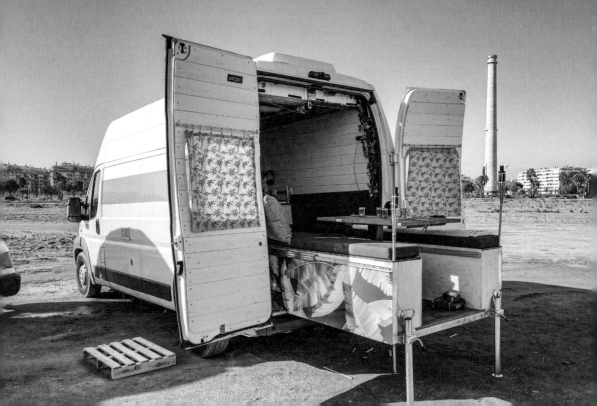

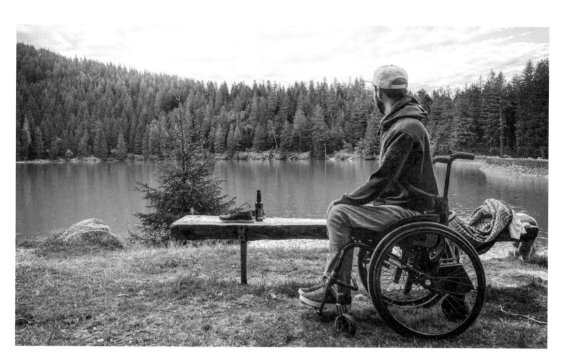

THREE ESSENTIAL ITEMS

→ Gripping tongs for grabbing stuff without bending down

→ Matches for a campfire

→ Tools to fix problems yourself on the road

MOST MEMORABLE DESTINATION

→ Andalusia, Spain – turquoise water surrounded by mountains, a painted landscape with no people for miles around. I have never experienced the tranquillity of that place anywhere else

→ If you like the sound of Tarek's peaceful Andalusian adventure, then consider planning a road trip to:
 Liguria, Italy
 Cypress Hills, Canada
 Gangtok, India

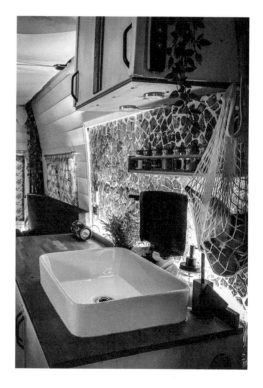

SKEIDARAR

 @skeidarar

 Germany

Just do it your way

 2019 Mercedes Benz Arocs 1835 A 4×4

For many modern-day adventurers, road life inspiration comes through social media outlets such as Instagram or Tiktok. But for Simone and Rüdiger, it all started in 1984 with a borrowed tent and a trip through France in a Ford Fiesta. What followed was a thirty-three-year love affair with campervans, until an off-grid adventure to the Arctic Circle prompted the couple to buy a truck-based expedition vehicle for the ultimate off-road experience. In 2019, after two years of research and planning, they purchased their mammoth Mercedes Benz Arocs 1845 A 4×4 and set about planning trips to the most remote parts of the planet.

Simone and Rüdiger's camper is designed for living off-grid for long periods. Their self-sufficient off-road house comes complete with a 590-litre diesel tank (more than 150 US gallons), which can keep them on the road for just under 2,500 kilometres (around 1,500 miles), and the 650-litres (170-US gallon) freshwater tank is big enough to provide a refreshing shower every day for two weeks. With a compressor fridge on board powered by an impressive battery and solar panel setup, they can keep all their consumables fresh in hot temperatures. Their 71 kg (157 pound) gas storage fuels all their hot water and heating, allowing the couple to be comfortable in temperatures as low as -25°C (-13°F).

Having such a large motorhome comes with the benefits of lots of storage, and Simone and Rüdiger keep their cupboards stocked up with long-life products at all times. They keep everything from snow chains to beach towels securely stowed away, always ready for adventure

at a moment's notice. With a separate toilet and shower room, a light and airy panoramic living room, and a spacious kitchen for cooking and freezing meals on the go, Simone and Rüdiger have all the comforts of home with them no matter where a road or dirt track might take them.

Parking their Mercedes Arocs is easier than you might think too. Instead of wild camping, Simone and Rüdiger visit remote parking spots, never usually staying in one place longer than one night on the way to their off-grid destination. They often use Google Maps to find open spaces near water and spend a lot of time hiking in nature, eating outdoors and travelling slowly as they soak up the beautiful scenery all around them. Their travelling home might be big, but it's the little things that excite this adventurous outdoor couple.

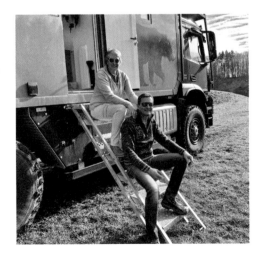

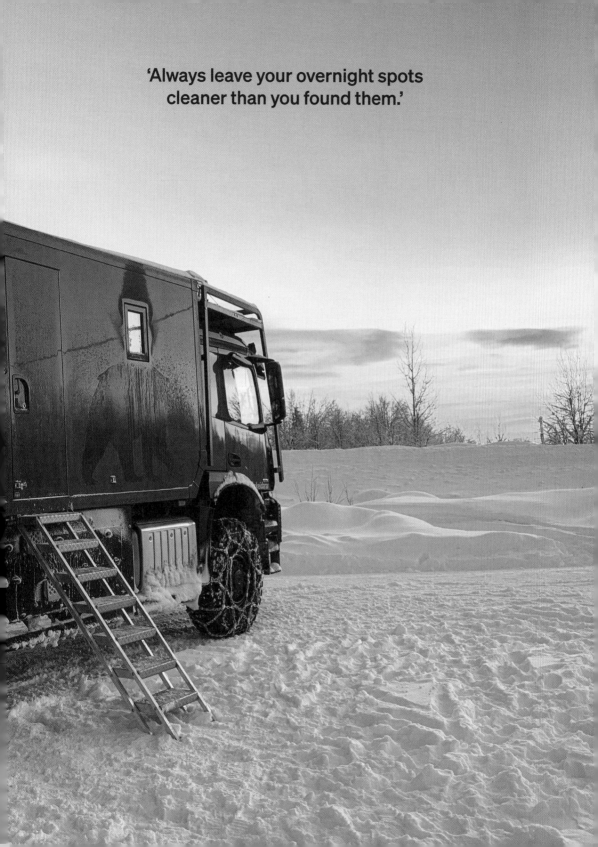

'Always leave your overnight spots cleaner than you found them.'

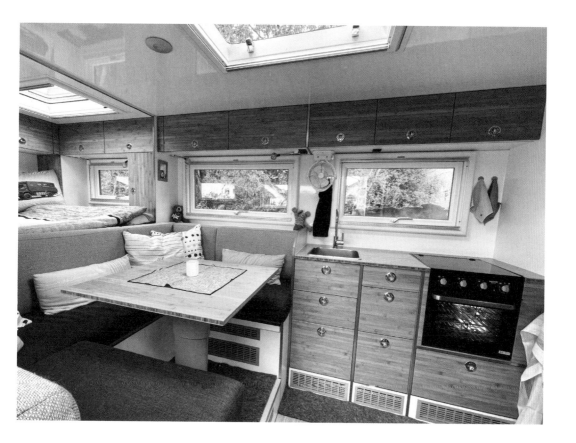

THREE ESSENTIAL ITEMS

→ Shower

→ Toilet

→ The freedom to roam off-road that our truck provides

MOST MEMORABLE DESTINATION

→ Finland in the Arctic winter

→ If you like the sound of Simone and Rüdiger's off-grid adventure to snowy Finland, then why not consider planning your own expedition to:
Målerås, Sweden
Banff National Park, Canada
Zermatt, Switzerland

BOUND FOR NOWHERE

Not here for a long time, here for a good time

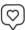 @bound.for.nowhere

 USA

 'Roxanne' – 2019 Toyota Tundra with a Flatbed Four Wheel Camper

MAK and Owen are no strangers to living off-grid. For the past five years, they have been living and working on the road as freelance designers, photographers and videographers, exploring every inch of North America from the Alaskan tundra to the southern reaches of Mexico. After gradually upgrading from a VW Vanagon Westfalia through two other Toyota trucks, they have finally found their perfect set up in a Flatbed Four Wheel Camper and Toyota Tundra, a combo more than capable of ferrying them to remote beauty spots that complement their adventurous lifestyle.

Their pop-up Four Wheel Camper has been designed around MAK and Owen's every need, and their truck has no troubles crossing rugged terrain and reaching places that a conventional van would struggle to navigate. Built for a life away from campsites in the heart of nature, it's a comfortable place to work and explore in every season and the perfect road life setup for reaching out-of-the-way hotspots for climbing, surfing, fishing and hiking.

Power is essential when it comes to MAK and Owen's life on the road. With an impressive solar and lithium battery set up on board, they can work everywhere from shopping mall car parks to the deepest reaches of the backcountry. They're also kitted out to get themselves and others out of sticky situations after installing recovery equipment such as a winch, tow straps and an air compressor into their build. Setbacks are bound to happen out in the wild, but rather than failing to prepare, MAK and Owen are ready for anything that Mother Nature might throw their way.

The transition from MAK and Owen's old life to their new routine as off-grid explorers took around two years, with the couple planning and preparing every aspect of their new freelance careers. Like many road lifers, they hotspot from their mobile phones to connect to the internet, but they also frequent local libraries in the towns they visit when needing to upload large projects, and they can pinpoint a map of their favourite buildings across the whole of North America. Now, instead of waking up and heading to the office, their day begins with a coffee while looking out over a beautiful vista. They work in the morning, freeing up the afternoons for

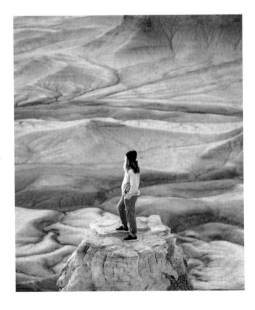

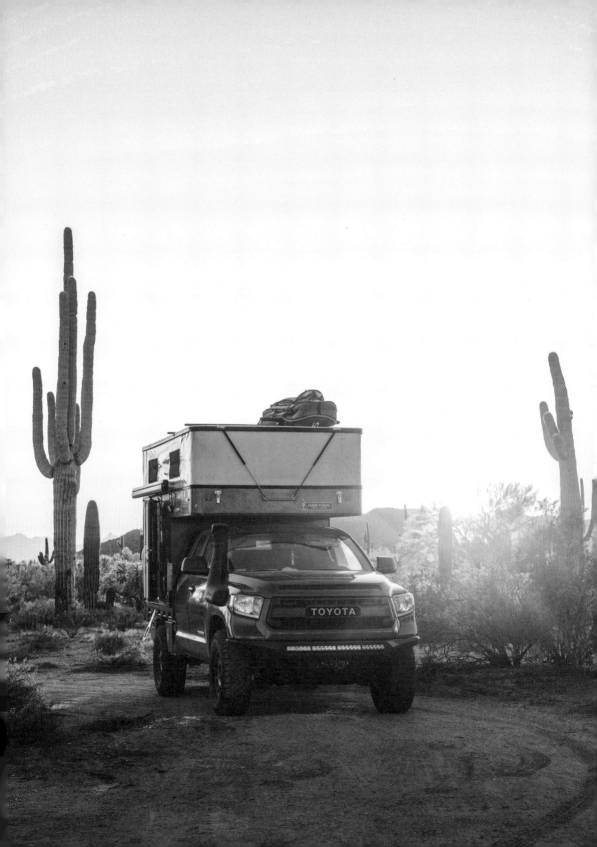

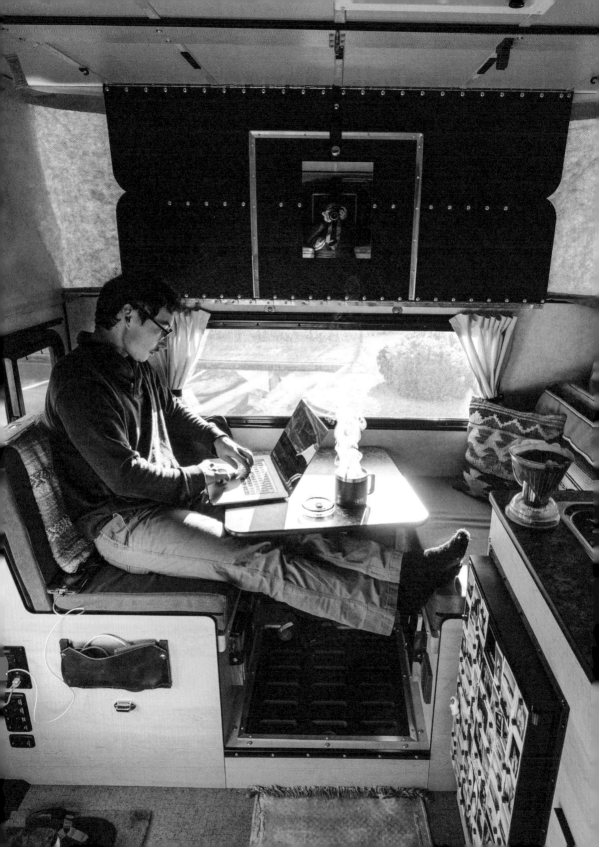

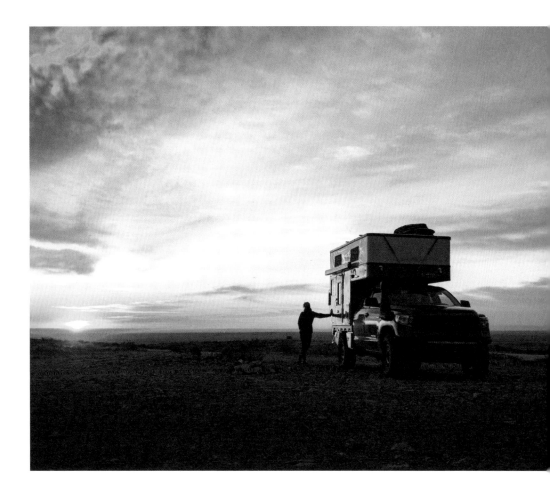

hikes and exploring their surroundings, finishing the day with a cold beer while watching the sun descend beyond the horizon.

When it comes to finances, MAK and Owen use their slow pace of life to their advantage. Their freelance jobs might not come with health insurance, but life on the road costs far less than living in a house, even after paying for insurance and other day-to-day expenditures. Travelling slowly allows them to make the most of each unique location on their journey, giving them time to explore each park up fully without rushing and keeping fuel costs down at the same time. They've frequently managed to make one tank of fuel (gas)

last up to two weeks in this way, all while paying no rent and turning the whole of North America into their front lawn.

During their travels, MAK and Owen have learned what it truly means to work as a team. They find solace and strength in each other through difficult times and relish in the freedom to be themselves in some of the world's most remote places. After five years of travelling all over the United States, they are following the pull of international travel, starting with a trip exploring the wonders of Japan.

THREE ESSENTIAL ITEMS

→ Our digital and film camera gear – we can't collect souvenirs; photos and video is our way of making something we can look back on

→ Coffee gear – we have a foldable pour-over, a scale/timer, a grinder and a kettle with a thermometer

→ Our minimal tent – this allows us to park and go out on foot for a few days into more remote areas

MOST MEMORABLE DESTINATION

→ We'd have to say Nova Scotia and Newfoundland, Canada. We found the area unspeakably beautiful; the people were kind, and it was some of the best camping we'd had in a really long time

→ If you're excited by the waterside towns of Nova Scotia or the vast valleys of Newfoundland, then why not consider visiting:
 Hallstatt, Austria
 Cinque Terra, Italy
 Port Fairy, Australia

‘Learn as you go and stay flexible.
You can figure the rest out on the move!’

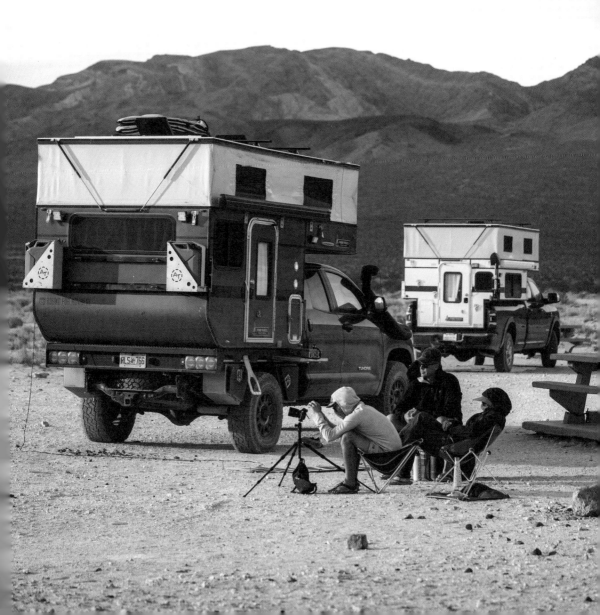

GREG AND RICK

Live unapologetically

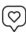 @greg_mares

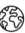 USA

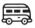 'Moby' – 2018 RAM ProMaster Highroof

Sometimes road life can become a full-time way of living without you ever expecting it. Back in 2019 when Greg picked up his RAM ProMaster with a view of heading out on long road trips with his partner Rick and dog Stella, he never imagined living a wholly nomadic lifestyle. Fourteen months and thirty-nine countries later, Greg and Rick have carved out a completely unique journey that is inherently personal, filled with irreplaceable experiences, jaw-dropping landscapes and one-of-a-kind humans that help to shape their future adventures.

As a seasoned woodworker with plenty of tiny-home-building experience under his belt, Rick didn't need any persuasion to embark on a conversion adventure with Greg. Taking time to research other people's layouts on social media and drafting up countless designs, they settled on the boxy ProMaster frame, allowing for a full-sized bed across the width of the van and more space to utilize, all for a lower cost than the same would be for a conventional Sprinter van, with both vehicle and build coming in at a respectable cost of around £18,000 (around $24,000).

Greg and Rick start every day with a coffee and good food for the day ahead. Waking with the sun, Greg takes each day as it comes, getting out into nature to pursue his passions of photography and videography, pushing himself creatively while capturing work that he connects with on a deeply personal level. As well as earning money from Greg's creative endeavours and trading cryptocurrency, this travelling couple also generate income through Rick's work building custom furniture and remodelling homes in the different states they visit. Living everywhere and nowhere allows Rick to spend long periods of time in one place without the faff of renting a different property every time, leaving him free to move onto the next exciting project while taking in the beautiful American landscape along the way.

The transition from Greg and Rick's two-bedroom house and garden to a home on wheels was by no means an easy process. Learning to live together with a dog in such a small space and even coping with the initial lack of structure took time, and they are continuously learning things about both themselves and each other. Their off-grid adventures across America have helped them to become less introverted and find ways to create personal space without being physically distanced. They make time for individual hobbies and time spent on themselves as well as enjoying the wonders of nature together. For Greg, Rick and Stella, road life is a liberating, honest way of life that, while challenging at times, has opened up a world filled with possibilities.

'Roll with change as it comes! Learning to embrace uncertainty and live in the moment is one of the most beautiful things about nomadic living.'

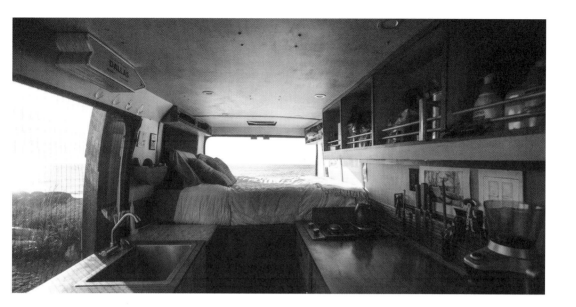

THREE ESSENTIAL ITEMS

→ Composting toilet

→ Solar panels

→ Data plan (WiFi, modem, smartphones with hotspots)

MOST MEMORABLE DESTINATION

→ Crystal Geyser, Utah. Crystal Geyser is a place we stayed at on a whim after about a month on the road. In the middle of nowhere, outside of Moab on the Green River, it's a natural geyser that shoots water out of the earth and over 9 metres (30 feet) into the sky, sometimes multiple times a day. It's hard to put into words the feeling that encompassed us while at that spot

→ If you're inspired by Crystal Geyser and the phenomenal landscape found throughout Utah, then why not consider visiting:
> Huanglong (Yellow Dragon Mountain), China
> Pamukkale, Turkey
> Great Geysir, Reykjavik, Iceland

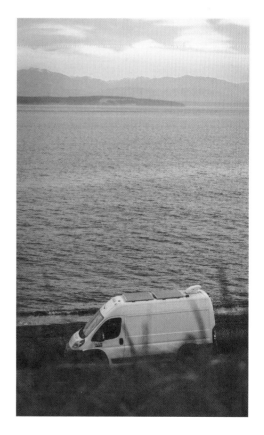

KENDEL STRACHAN

Braving harsh climates while experiencing true freedom

 @kendal.strachan

 USA

 'Streamy' – 2018
Airstream Classic

For some people, the idea of braving the harsh Alaskan climate in a 10-metre (33-foot) Airstream might be too much to bear. But for Kendal Strachan and her husband Collin, their off-grid lifestyle is all about facing challenges and boondocking (wild camping) in some of the most beautiful places that North America has to offer. After purchasing 'Streamy' back in 2019 and visiting national parks while continually heading towards warmer climates, this adventurous couple did a complete U-turn and headed north, swapping the Californian coast for the stunning snowy mountains of America's biggest and coldest state.

It goes without saying that the weather patterns in Alaska are anything but predictable and often extreme, but Kendal thrives in situations that challenge her mentally and physically. For her, road life is synonymous with nature, and living in her Airstream allows for immediate and endless access to hiking through glaciers, running through the rich colours of autumn and driving along windy mountain roads in search of new and amazing places to call home.

Like many people looking to kickstart road life, Kendal didn't realize about the sense of freedom that comes from boondocking. After buying a generator for power, she and Collin now park up in stunning locations for free, saving thousands of dollars on RV parking lots every year. Alaska certainly isn't short of free land to park up on but having a 10-metre (33-foot) camper trailer can sometimes prove difficult to park, meaning Kendal is more than used to parking beside a ravine one day and a gravel pit the next. Still, beauty can be found in the strangest of places, and with a cosy trailer to come back to, even a quarry can feel like home.

Kendal and Collin chose an Airstream over a campervan for several reasons, though chiefly for the classic aesthetic and sense of excitement that seeing it after returning for a long hike brings. Instead of blotting out the landscape, it adds to every photo the couple take while documenting their many adventures. It also provides way more space than a regular camper while giving them the option to separate their vehicle and living space when heading to buy groceries or visiting libraries in places with bad mobile internet.

Kendal's airstream is like a Tardis when it comes to storage, with secret nooks hidden under both the bench seating and bed that can house all their adventurous equipment plus space to store bulky items in the trailer's exterior and truck bed. Kendal loves the fact that she now lives a minimalistic lifestyle and takes great care when choosing what to buy, revelling in a life where experiences have greater value than things that spend all their lives in a cupboard.

Taking this leap of faith and doing something that initially felt uncomfortable has been so important to Kendal and Collin. It has taught them the importance of resolving differences and how to work together, nurturing each other's strengths. Their time inside 'Streamy' might not last for ever, but the lessons they have learned through road life certainly will.

'This lifestyle is hard, but going into it knowing that it isn't always perfect helps overcome hard days and makes you appreciate the good days.'

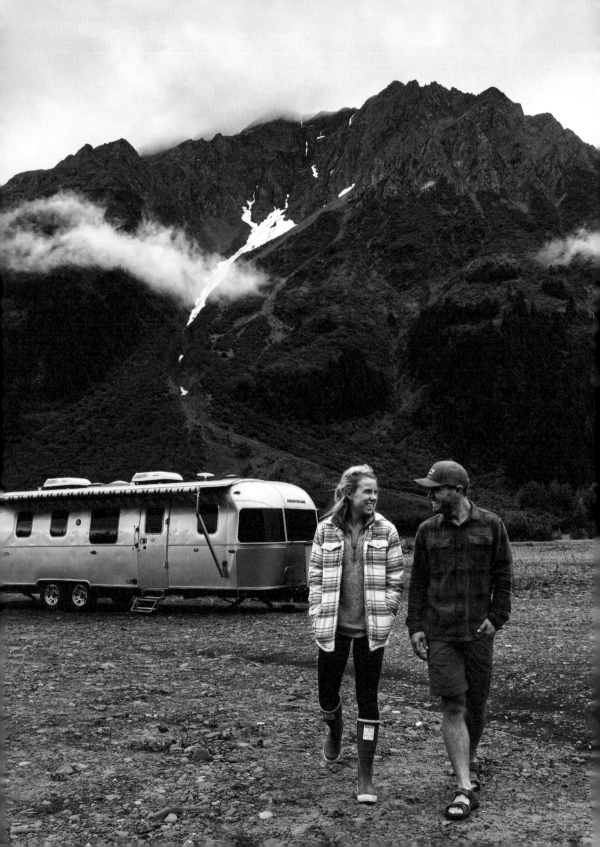

THREE ESSENTIAL ITEMS

→ My toilet – I lived for a few weeks without one and it made me so appreciative of mine

→ The kitchen – the counter space is great, we have a three-burner stove, a full-size fridge and large farmhouse sink

→ Heater – this is a new thing that I am now so grateful for as we live in colder climates

MOST MEMORABLE DESTINATION

→ Alaska is hands down my absolute favourite place that we have been and it may just end up being home for us!

→ If Kendal and Collin have made you fall in love with the idea of Alaska, then why not consider planning a road trip to:
 Siberia, Russia
 Uunartoq Hot Springs, Greenland
 Kosciuszko National Park, Australia

I VAGABONDI SULLA STRADA

At home in the wilderness

 @ivagabondisullastrada

 Italy

1989 Iveco Daily
Hi-Roof

Carlotto and Fabrizio fell in love with road life after a summer vacation to celebrate the end of their studies. With a tent in tow, they explored the beauty of the island of Corsica in an off-grid vehicle and developed a taste for life off the beaten track. They bought their fantastic 1989 Iveco Daily 4×4 back in September 2000 and finished their conversion five months later, heading to the sun-kissed beaches of Sardinia for the off-road adventure of a lifetime.

Living off-grid away from civilization requires careful thought, but Carlotta and Fabrizio have got all the bases covered. They travel with 250Ah of LiFePo4 batteries and two photovoltaic panels adding up to 410W. Their 5 kilogram (11 pound) gas cylinder provides fuel for cooking and hot water for a month, and two 110-litre (around 30 gallons) water tanks carry enough water for a week with daily showers through the summer. They wash their clothes using a watertight washbag and dry on the go, and their compressor fridge allows for a week's worth of fresh groceries for sumptuous meals in the great outdoors.

Having spent lots of time exploring remote places, Carlotta and Fabrizio both agreed that an onboard shower was one of the most important things to consider in their van build and was the main reason they opted for a hi-roof van. Their retractable shower can be mounted as and when they need it, tucking away inside their ample storage space when not in use. This allows them to shower no matter where they are without having to worry about passers-by when parking in unsecluded locations.

Despite having an off-grid van and with the ability to stock up with enough clothes and provisions for life away from cities and villages for weeks, Carlotta and Fabrizio practise a minimalistic lifestyle. They only bring what they need along for the ride and try to live a clutter-free life, a great practice for anyone thinking of downsizing into a tiny home. They also know that life on the road requires being able to adapt, and that a crowded water fill-up station can sometimes provide a comfortable and safe place to park while visiting major cities.

If there's one couple that really embody the mantra of 'home is where you park it', then it's I Vagabondi Sulla Strada. No matter where they go, they have a little slice of heaven parked nearby, their own rolling retreat where they feel protected and pampered in equal measure. And the best part is that this accommodation is completely free to stay in!

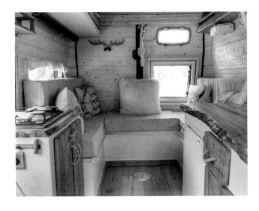

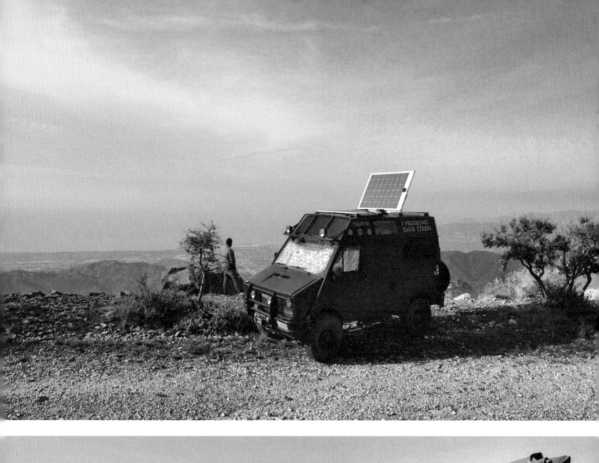
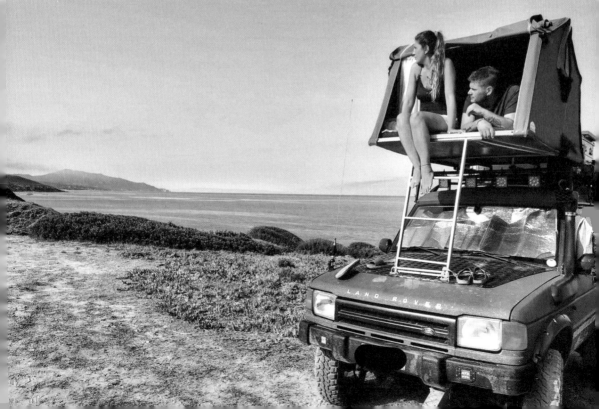

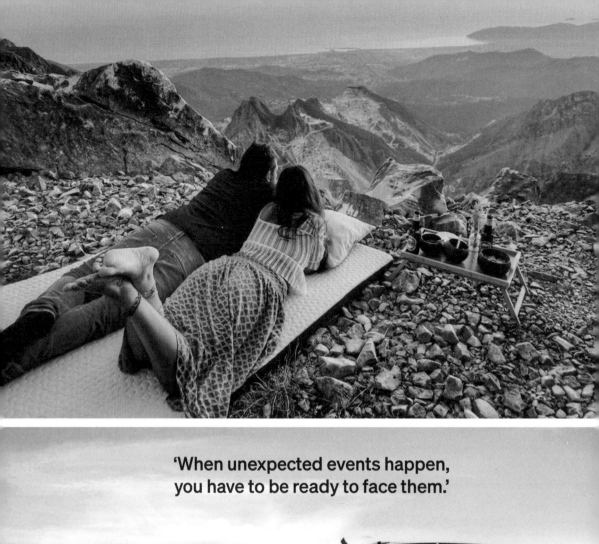

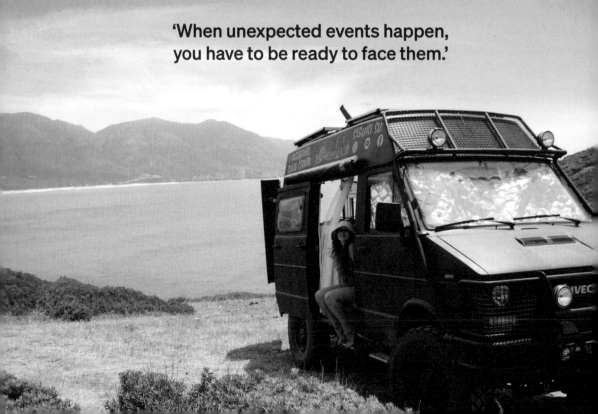

'When unexpected events happen,
you have to be ready to face them.'

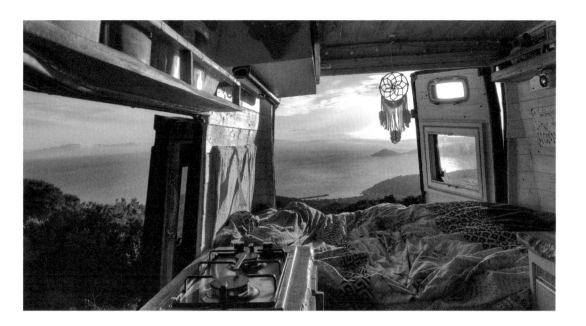

THREE ESSENTIAL ITEMS

→ A head torch, very important for cooking and gathering wood outside when it gets dark, and also not disturbing the wildlife

→ Our toolbox, which can be useful in any situation

→ Our camera, which allows us to immortalize the unique landscapes in which we happen to find ourselves

MOST MEMORABLE DESTINATION

→ Sardinia, because behind its facade of crystal-clear sea and luxury that everyone knows, it hides a green and little-known hinterland, as well as wild and windswept coasts that we can reach thanks to our off-road vehicle

→ If you're a fan of the flamingos on Stintino Beach or the azure waters at Cala Luna, then why not try:
Diaz Beach, South Africa
Flamingo Beach, Aruba
Cathedral Cove, New Zealand

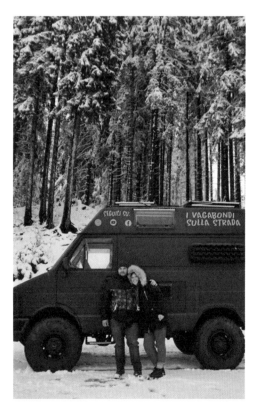

FIVE ESSENTIAL OFF-GRID COOKING UTENSILS

1. RIDGEMONKEY SANDWICH TOASTER XL

Cook everything from paninis to pizzas on any heat source. I've even cooked fish fingers in a log fire with one of these before.

2. OMNIA OVEN

Perfect for baking bread and cakes, cooking oven chips and whipping up tasty pies and casseroles on the go.

4. ZYLISS EASY PULL MANUAL FOOD PROCESSOR

Chop and dice without spillages and stress thanks to this hand food processor with sealed cup.

3. WACACO PORTABLE ESPRESSO MACHINE

261 psi and holds 80ml (3fl oz) of water It's simple to use and protected by the detachable cup. A must-have for road lifers that need a kickstart in the morning.

5. BIOLITE KETTLE POT

Make soup, brew tea, stew meat and vegetables, or whip out a tasty pasta dish. This kettle pot can be used for all types of drinks and dishes, just make sure to wash it thoroughly in-between!

DIRECTORY

BUSINESSES
Bialetti – *www.bialetti.com*
BioLite – *www.bioliteenergy.com*
Four Wheel Campers – *www.fourwheelcampers.com*
HydroFlask – *www.hydroflask.com*
InstantPot – *www.instanthome.com*
KingCamp – *www.kingcampoutdoors.com*
LifeSaver – *www.iconlifesaver.com*
Nemo – *www.nemoequipment.com*
Omnia Oven – *www.omniasweden.com/us*
Portable Power Technology – *www.portablepowertech.com*
RidgeMonkey – *www.ridgemonkey.co.uk*
Scrubba – *www.thescrubba.com*
TomTom – *www.tomtom.com*
Urbanista – *www.urbanista.com*
Wacaco – *www.wacaco.com*
WeBoost – *www.weboost.com*
Zyliss – *www.zyliss.com*

SOCIAL RESOURCES
Diversify Vanlife – *www.diversifyvanlife.com*
Vanlife Pride – *www.instagram.com/vanlifepride*

TRAVEL APPS
Apple Maps – *www.apple.com/maps*
Brit Stops – *www.britstops.com*
Google Maps – *www.googlemaps.com*
iOverlander – *www.ioverlander.com*
Park4Night – *www.park4night.com*
WikiCamps – *www.wikicamps.co*

TRAVEL REGULATIONS
Bureau of Land Management – *www.blm.gov/programs/recreation/camping*
Lake District Camping - *www.lakedistrict.gov.uk/visiting/where-to-stay/wild-camping*
Scandinavian Camping - *www.visitsweden.com/what-to-do/nature-outdoors/nature/sustainable-and-rural-tourism/the-right-of-public-access*
Scotland Camping - *www.visitscotland.com/accommodation/caravan-camping/wild-camping*
UK Camping – *www.trespass.com/advice/wild-camping-legal*
USDA Forest Service – *www.fs.usda.gov/visit/know-before-you-go/camping*

VEHICLES
Airstream – *www.airstream.com*
Carthago – *www.carthago.com*
Dodge – *www.dodge.com*
Ford – *www.ford.com*
Fiat – *www.fiat.com*
GMC – *www.gmc.com*
Iveco – *www.iveco.com*
LDV – *www.ldv.co.uk*
Mazda – *www.mazda.co.uk*
Mercedes – *www.mercedes-benz.com*
Navistar – *www.navistar.com*
Nissan – *www.nissan.co.uk*
Ram – *www.ramtrucks.com*
Toyota – *www.toyota.com*
Vauxhall – *www.vauxhall.co.uk*
VW – *www.vw.com*

INDEX

Destination suggestions are listed under country names.

75 Vibes 72–77

A

A Bus and Beyond 58–63
adventurers see thrillseekers and adventurers
Airstream Classic 174–179
Albania 105
 Karaburun Peninsula 147
 Ksamil Beach 67
Alexandr and Yana 112–115
Anniek and Mattias 102–105
Argentina
 Mounte Fitz Roy 62
Asobolife 94–97
Australia
 9 Mile Beach, Esperance 75
 Bunda Cliffs 151
 Gibb River Road 147
 Great Ocean Road 53
 Kata Tjuta 49
 Kosciuszko National Park 177
 Port Fairy 168
 Shark Beach 139
 Shoalhaven 105
 Tasmania 29
Austria
 Hallstatt 168

B

batteries 34, 50, 86, 129, 140, 160, 164
 LiFePo4 batteries 94, 152, 180
beds 50, 54, 85, 86, 90, 93, 112,
116, 124, 148, 156, 170, 174
Biolite Kettle Pot 185
BIPOC 26
Blix & Bess 34–37
Bluetooth speakers 29, 69
Bolivia
 Uyuni Salt Flats, Bolivia 123
Bound For Nowhere 164–169
Brazil
 Sugarloaf Mountain, Rio de Janeiro 62
Bug Slayer 110
burners 54, 90, 93, 148, 177
Butt Hike 144

C

cameras 40, 68, 89, 129, 135, 153, 168, 183
camping chairs 69
Canada
 Alcan Highway 127
 Banff National Park 163
 Cypress Hills 159
 Kluane Lake, Yukon Territory 135
 Nova Scotia and Newfoundland 168
 Pacific Rim National Park Reserve, British Columbia 57
Caribbean, Dutch
 Flamingo Beach, Aruba 183
Carthago 144–147
cats 14–17, 97, 143
Cheer, Charly 124–127
children 22–25, 58, 64, 86–89, 90, 112–115
Chile
 Termas de Laguna Verde 85
 Todos los Santos 135
China
 Huanglong (Yellow Dragon Mountain) 173
 Zhangye Danxia Landform Geological Park 29
cleaner living 131
 Helen Louise 148–151
 Let's Play Ride and Seek 136–139
 Route Del Sol 132–135
 solar power cheat sheet 152–153
 The Trash Traveler 144–147
 We Travel By Bus 140–143
Climbing Van 82–85
coffee, making 168
 coffee percolators 105
 Moka stovetop coffee pots 81, 89
 Wacaco portable espresso machine 185
Colombia
 El Peñon de Guatapé 62
Comley, Dale The Van Conversion Bible 82
costs 30, 32, 101, 106, 116, 136, 167
 how to budget for full-time road life 128–129
 van conversion 54, 90, 102, 112, 120, 132, 170
COVID-19 pandemic 40, 116
Croatia
 Brač 110
Curly Hair Camping 120–123

D

digital nomads 13
 Blix & Bess 34–37
 how to become a digital nomad 42–43
 Irie to Aurora 26–29
 Rainbows on the Road 22–25
 The Brown Vanlife 38–41
 The Indie Projects 14–21
 TREAD the Globe 30–33

disabled people 46–49, 156–159
Diversify Vanlife 26–29
Dodge B200 Tradesman 38–41
Dodge Robinhood Archer 124–127
dogs 22, 26, 38, 50, 53, 54, 57,
 58–61, 102, 136, 139, 170
drills 49

E

entertainment costs 129
everyday supplies costs 129

F

Fiat Ducato 30–33, 120–123,
 156–159
Finland 163
fly screens 49
food costs 128
Ford Transit 50–53, 54–57, 94–97
France 85
 Lake Annecy 135
 Lion-sur-Mer 147
 Restonica Gorge, Corsica 110
 Rhône Alps 18
 Verdon Gorge 97
fridges 97, 115, 160, 177, 180
fuel costs 128

G

gas 33, 82, 112, 160, 180
generators 14, 174
GMC Vandura 140–143
Google Maps 105, 160
Google Satellite View 82
GPS trackers 17, 99
Greece 110
 Meteora 49
Greenland
 Uunartoq Hot Springs 177
Greg and Rick 170–173

H

Handley, Dan 54–57
head torches 183

heaters 37, 177
Helen Louise 148–151
Henry, Mao 116–119
hotspotting 14, 22, 26, 127, 148,
 164, 173

I

I Vagabondi Sulla Strada 180–183
Iceland 143
 Great Geysir, Reykjavik 173
 Saltvik 139
 Skaftafell 89
 The Westfjords 57
 Vík í Mýrdal 18
India
 Anjuna Beach, North Goa 105
 Gangtok 159
Instagram 38, 50, 72, 109, 116, 160
Instant Pot 97
International Navistar E-Star
 132–135
internet 14, 18, 22, 25, 26, 30, 34,
 61, 164, 174
Ireland, Republic of
 Macgillycuddy's Reeks 57
 Sheep's Head Peninsula 33
 Cliffs of Moher 151
Irie to Aurora 26–29
Italy
 Amalfi Coast 127
 Cala Goloritzé, Sardinia 105
 Cala Luna, Sardinia 37, 183
 Cinque Terra 168
 Dolomites 119
 Liguria 159
 Sardinia 110, 183
 Stelvio Pass 53
 Stintino, Sardinia 75, 183
Iveco Daily 4 × 4 180–183

J

Japan
 Fumotoppara Campground 119

K

kettles 67, 168

Biolite Kettle Pot 185

L

laptops 40, 81, 116, 135, 152
Let's Play Ride and Seek
 136–139
LGBTQIA+ 34
LifeSaver Jerrycan 33
locks 98
Low, Charlie The Van Conversion
 Bible 82
Luton Box Van w22–25

M

maintenance costs 129
Mali Mish 86–89
Marine Conservation Society 148
matches 129, 159
Mazda Bongo 116–119
Mercedes Arocs 160–163
Mercedes Sprinter 14–21, 82–85,
 86–89, 90–93, 106–111, 136–139
Mexico
 Copper Canyon 97
 Tulum 85
Moka stovetop coffee pots 81, 89
Morocco
 Dadès Gorge 115
 Tinfou Dunes 81
Myanmar
 Bagan 123

N

Namibia
 Fish River Canyon 115
 Kolmanskop 81
National Forest Foundation 136
New Zealand
 Cathedral Cove 183
 South Island 29
 The Remarkables 33
Nissan Traffic 4 × 4 102–105
Nomads at the Intersections 26
Norway
 Atlantic Road 53

Cape Enniberg, Faroe Islands 151
Geirangerfjord 143
Lofoten Islands 18
Mykines, Faroe islands 143

O

Off the Grid With 106–111
off-grid explorers 155
Bound For Nowhere 164–169
five essential off-grid cooking
utensils 184–185
Greg and Rick 170–173
I Vagabondi Sulla Strada
180–183
Kendel Strachan 174–179
Skeidarar 160–163
Tarek 156–159
online earning 42–43
ovens 90
Omnia Oven 184

P

Park4Night 58, 102, 105, 109, 148
Parris, Alicia 78–81
Perkins, Leon 90–93
Peru
Colca Canyon 97
phones 14, 22, 105, 116, 123, 127,
164, 173
phone bills 129
satellite phones 99
Portugal 147
Cape Espichel 67
Poste Restante 17
power packs 68, 116, 119
pressure cookers 97

R

Rainbows on the Road 22–25
RAM ProMaster 34–37, 170–173
RidgeMonkey sandwich toaster
62, 184
road life 7–9
cleaner living 131
digital nomads 13

off-grid explorers 155
shoestring travellers 101
thrillseekers and adventurers 71
weekend warriors 45
roadschooling 22–25, 86
Route Del Sol 132–135
Russia
Lake Baikal 29
Siberia 177
Sulak Canyon 115

S

sandwich toasters, stovetop 62,
184
school bus, converted 78–81,
140–143
security 98–99, 109
social media 99
trust your gut 99, 148
shoestring travellers 101
Alexandr and Yana 112–115
Anniek and Mattias 102–105
Charly Cheer 124–127
Curly Hair Camping 120–123
how to budget for full-time road
life 128–129
Mao Henry 116–119
Off the Grid With 106–111
Shot with Glass 50–53
showers 33, 46, 58, 75, 102, 112,
115, 120, 144, 160, 163, 180
outdoor showers 50, 82, 85,
140, 147
portable showers 68
signal boosters 14, 26, 29
weBoost 34
sine wave inverters 153
sinks 85, 93, 177
Skeidarar 160–163
Slovenia
Lake Bled 135
solar power 18, 33, 90, 116, 127,
152–153, 164
solar charge regulators 153
solar panels 14, 34, 50, 75, 86,
89, 94, 112, 123, 131, 132, 140, 148,
151, 152, 160, 173, 180

solar powered vehicle 132
solo travelling 106–109, 116, 148
South Africa
Diaz Beach 183
Drakensberg 93
Kruger National Park 37
Spain
Andalusia 159
Bardenas Reales 49
Far de Formentor 67
Sierra Nevada 25
split charge relays 153
storage 71, 82, 106, 110, 112, 116,
174, 180
gas storage 160
low-level storage 46
under-bed storage 85, 90
stoves 86, 140, 177
Strachan, Kendel 174–179
Sweden
Målaerås 163
Switzerland
Bernese Highlands 93
Swiss Alps 62, 89
Zermatt 163

T

Tarek 156–159
The Adventure Squad 64–67
The Brown Vanlife 38–41
The Indie Projects 14–21
The Trash Traveler 144–147
thrillseekers and adventurers 71
75 Vibes 72–77
Alicia Parris 78–81
Asobolife 94–97
Climbing Van 82–85
Leon Perkins 90–93
Mali Mish 86–89
staying safe on the road 98–99
TikTok 160
toilets 25, 33, 86, 110, 115, 136,
156, 160, 163, 177
composting toilets 37, 54, 131,
140, 173
wild poos 67, 102
tolls 128

tools 49, 119, 159, 183
tourism costs 129
Toyota Tundra 164–169
trackers 17, 99
TREAD the Globe 30–33
Turkey
 Cappadocia 25, 123
 Kaş Turkey 40
 Pamukkale 85, 173
 Rize 33

U

UK 93
 Brecon Beacons, Wales 119
 Causeway Coast, Northern
Ireland 127
 Duncansby Head, Scotland 18
 Giant's Causeway, Northern
Ireland 25
 Isle of Skye, Scotland 18
 Lake District, England 18
 Lochnagar, Scotland
 pembrokeshire Coast, Wales 151
 Scottish Highlands 57
 Strumble Head, Wales 67
US
 Alaska 29, 127, 177
 Antelope Canyon, Arizona 25
 Appalachian Mountains 93
 Big Bend National Park, Texas 37
 Crystal Geyser, Utah 173
 Curry Village, Yosemite
National Park 119
 Death Valley, California 49
 Glen Canyon 115
 Grand Canyon, Nevada 123
 Hapuna Beach, Hawaii Island 67
 Jerome, Arizona 81
 Katmai National Park, Alaska 143
 Makena Beach, Maui, Hawaii 110
 McCarthy, Alaska 89
 Nā Pali Coast. Kauai, Hawaii 40
 New Orleans, Louisiana 37
 Pigeon Point, California 67
 San Juan Islands 139
 Taos, New Mexico 81
 Todos Santos, California 40, 139

 White Sands National Park,
New Mexico 37

V

van hire 22, 155
vanlifepride 136
Vauxhall Movano Maxi-Roof 7–9
Vauxhall Vivaro 64–67
vlogging 30, 34
VW Bus 58–63
VW Crafter 46–49, 112–115
VW Kombi 72–77
VW T4 14, 148–151
VW Vanagon 26–29

W

Wacaco portable espresso
 machine 185
washbags 69, 180
 Scrubba Wash Bag 25
washing costs 129
water 17, 54, 75, 86, 93, 116, 123,
 124, 131, 132, 148, 156, 180
 water bottles 49, 69, 144
 water heaters 82, 112, 160
 water purifying 33, 139, 140
We Travel By Bus 140–143
weekend warriors 45
 A Bus & Beyond 58–63
 Dan Handley 54–57
 essential items 68–69
 Shot with Glass 50–53
 The Adventure Squad 64–67
 Wheelchair and Wanderlust
 46–49
wheel clamps 98
Wheelchair and Wanderlust
 46–49
WiFi 14, 18, 29, 173
woodburners 140

Y

YouTube 14, 18, 30, 34, 43, 58,
 112, 116, 120

Z

Zyliss Easy Pull manual food
 processor 185

ACKNOWLEDGEMENTS

First of all, I'd like to thank everyone who has bought a copy of this book.
I hope that it's inspired you to give road life a try and to head out on your very
own expeditions someday soon. Life is short, so fill yours with adventure.
Mum and Dad (or Jane and Tony to everyone else), thank you for always
believing in my travels and my career over the years, your unwavering support
means everything to me. Thanks to Brandon for giving me a chance as a
journalist back in 2017 and the adventures we had with Van Clan; to Dave and
Ilse for always being a phone call away when things get stressful; to Chris, Al,
and Josh for giving me space to write and raising my spirits through the tough
times; and to Margaret for introducing me to van life in the first place.
Thanks to Andy for your wisdom and cups of tea during the camper
conversion process; and thank you Bilbo for nudging me out of the door into
nature, even when it's raining. Thank you to the man that sold me the best
parmesan cheese I've ever had from the boot of his car in Sardinia, the kind
Swiss lady who paid for my parking in Bern and the Spanish farmer that pulled
me out of his muddy field; I'd have no anecdotes to tell at parties without you.
Thank you also to Dan Welty for being my guide around California over the
years and for laughing at my endless sarcasm. Finally, thanks to Alice and Joe
at the Quarto Group for all the hard work you've put into this project from the
very beginning and to all the contributors in this book for sharing your stories
with me; none of this would have been possible without you.

The publisher wishes to thank the many inspiring road lifers from around the
world who feature in this book for contributing their stories and providing
the reproduced images that accompany their entries, as well as Liam
Ashurst for the beautiful illustrations and icons. The images outside of the
featured entries (page numbers outlined below) are credited to the following
contributors:

Front cover: Kendal Strachan
Back cover: top We Travel by Bus; middle 75 Vibes; bottom Asobolife.
p.2 Climbingvan; p. 4 Greg and Rick; p. 6 The Brown Van Life; p. 8 Let's Play
Ride and Seek; p. 10–11 Kendal Strachan; p. 12 Blix & Bess; p. 44 Dan Handley;
p. 70 Climbingvan; p. 100 Anniek and Mattias; p. 130 We Travel by Bus;
p. 154 Bound for Nowhere.

Brimming with creative inspiration, how-to projects, and useful information to enrich your everyday life, quarto.com is a favourite destination for those pursuing their interests and passions.

First published in 2022 by Frances Lincoln, an imprint of The Quarto Group.
The Old Brewery, 6 Blundell Street
London, N7 9BH,
United Kingdom
T (0)20 7700 6700
www.Quarto.com

A catalogue record for this book is available from the British Library.
ISBN 978-0-7112-6916-3
Ebook ISBN 978-0-7112-6917-0
10 9 8 7 6 5 4 3 2 1

Illustrations by Liam Ashurst
Design by Mariana Sameiro

Printed in China